Expressive
watercolors

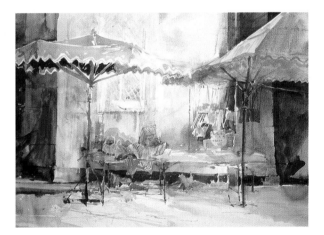

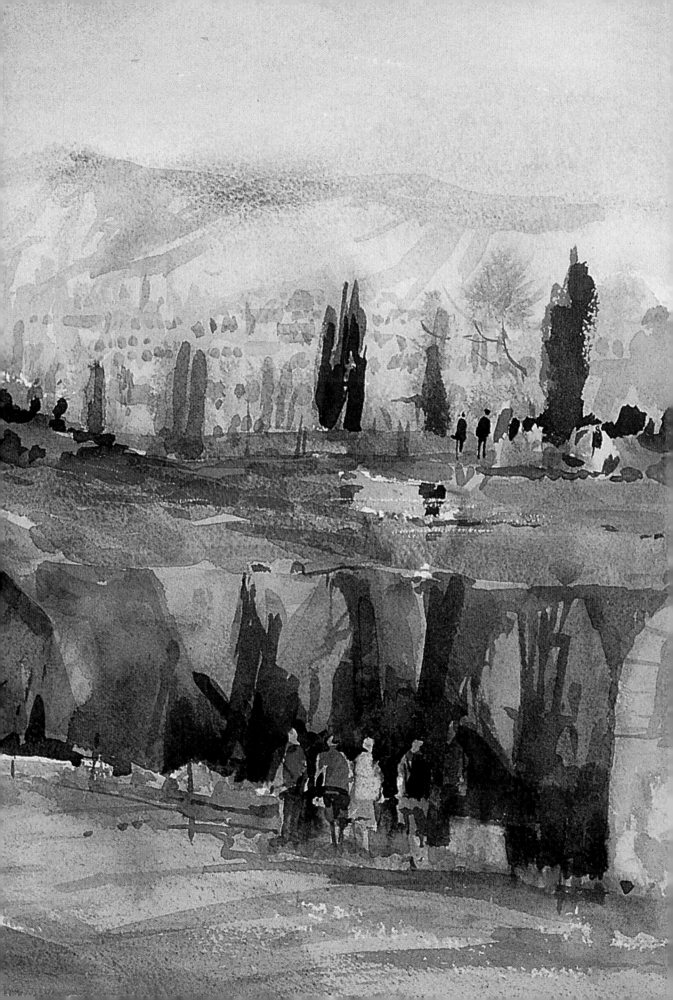

Expressive watercolors

Mike Chaplin *with* Diana Vowles

NORTH LIGHT BOOKS
Cincinnati, Ohio

First published in 2001 by
HarperCollins*Publishers*
77-85 Fulham Palace Road
Hammersmith, London W6 8JB

Distributed in 2002 to the trade
and art markets in North America
by North Light Books, an imprint of
F&W Publications, Inc.
4700 East Galbraith Road
Cincinnati, OH 45236
(800) 289-0963

The HarperCollins web site address is:
www.fireandwater.com

05 04 03 02 01
6 5 4 3 2 1

Illustrations © Mike Chaplin 2001
Text © Mike Chaplin and Diana Vowles, 2001

**A catalog record for this book is available from
the British Library**

Produced by Kingfisher Design, London
Art Director Pedro Prá-Lopez
Designer Frances Prá-Lopez
Photographer Jeremy Mc Cabe
Proofreader Patsy North

ISBN 1-58180-316-8

Color reproduction by Colorscan, Singapore
Printed and bound by Bath Press Color Books

Page 1: BOULOGNE MARKET (detail)
Page 2: CORINTH (detail) *see also page 60*
Page 3: THE ATRIUM, 10 x 15 cm (4 x 6 in)
Page 4: Mike and Gay in Salzburg (detail)

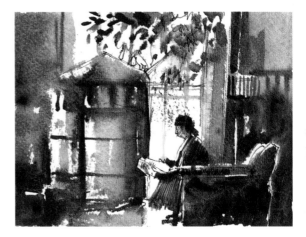

ACKNOWLEDGEMENTS

Many thanks are due to the people who have
helped me in the production of this book, not
least Diana Vowles, who has brought her great
skills in writing to bear on our many face-to-face
and phone conversations. My thanks go also to
Caroline Churton and Cathy Gosling at
HarperCollins; to Pedro and Frances Prá-Lopez,
for their care and expertise in designing the
pages; to Jeremy McCabe, a longstanding friend
who has patiently and beautifully photographed
many of the paintings; to Jenny Wheatley RWS
for kindly allowing us to reproduce the picture on
page 11; to Rosemary and David Jackson of ABS
Brushes, who have imparted knowledge gained
from four generations of fine brushmaking; to
Catherine Frood of St Cuthbert's Mill, Somerset;
who has been generous with advice on paper; to
Judy Dixey of the Bankside Gallery, London for
giving access to the RWS Diploma Collection
and allowing reproduction of the paintings on
pages 8, 9, and 10; and to Maidstone Museum
and Bentliff Art gallery for the loan of the paper
mould on page 20. Finally, many thanks to all my
family for being patient during many trips when I
have been engrossed in my sketchbook and above
all to my wife Gay for her unfailing support.

Mike Chaplin

CONTENTS

Introduction 6

Materials and Equipment 14
Focus on: grinding paint 18

Techniques 24
Focus on: working with mixed media 32
Demonstration: The sunken pond 34

Finding Your Inspiration 38
Focus on: using a camera for reference 48

Drawing 50
Focus on: bringing it all together 56

Tone and Colour 58
Focus on: using black and white 68
Demonstration: A quiet interior scene 70

Composition 74
Focus on: the Golden Section 80

The Natural Landscape 86
Demonstration: The harbour 102

The Urban Landscape 108
Demonstration: The street market 122

Index 128

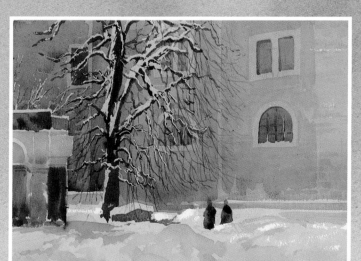

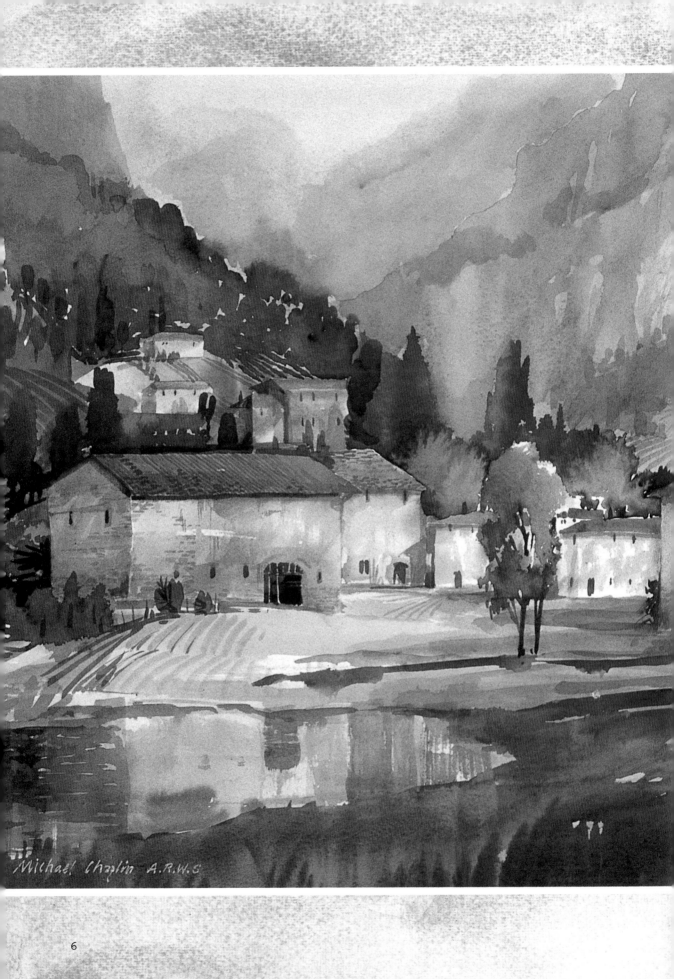

Michael Chaplin A.R.W.S.

Introduction

Watercolour is a medium that is capable of expression ranging from the most finely detailed of botanical studies to the most loosely gestural of marks. As a pigment it is easy to take out into the countryside and as a painting it is comfortable in a domestic environment and very portable for travelling exhibits. Such accessibility has gained it a unique standing with both professional and amateur artists.

◄ ITALIAN ALPS
45.5 × 66 cm (18 × 26 in)
This picture was painted in the studio from a small study I did on a coach on the way through Italy. I awoke at 6 am, with cold England several hours behind me, and drew a five-minute sketch to catch the memory of the warmth of the stones and the mountainous landscape.

A brief history

In its simplest form, watercolour was used in Europe more than 10,000 years ago when cave-dwellers of the Upper Palaeolithic era mixed red earth with water and used it to paint pictures of hunters and their prey on the cave walls. Yet in the Christian era in Britain, it was not appreciated as an art medium in its own right until the 19th century, when Queen Victoria gave the royal seal of approval that brought it firmly into the purview of the art establishment.

It may have been watercolour's simplicity that made it seem inferior to the business of sculpting and painting in oils. A provincial artist of the 15th century would have had to make do with what could be obtained in his village, and a simple starch glue combined with pigment was easier to achieve than the more complex binder and oils required for oil painting. Pigment itself was scarce, and the artist would often accept it as his fee.

By the 18th century, watercolour was well established as a means of making a topographical view of the landscape. While families making the Grand Tour of Europe took along their art tutor, in effect to provide the holiday photographs, professional artists such as Alexander Cozens (1717–1786) and Francis Towne (1740–1816) travelled extensively in Italy. It became part of the English tradition that one went abroad to do watercolour paintings of exotic ruins – except that they were known as watercolour drawings, as the medium was not even dignified by the recognition that it was paint.

▼ CADER IDRIS, NORTH WALES
John Varley (1778–1842)
24 × 35 cm (9¹/₂ × 13¹/₄ in)
In this classic landscape the tree acts as a framing device and points the eye towards the figures almost hidden below the bank. Their comparative insignificance was a new development in art.

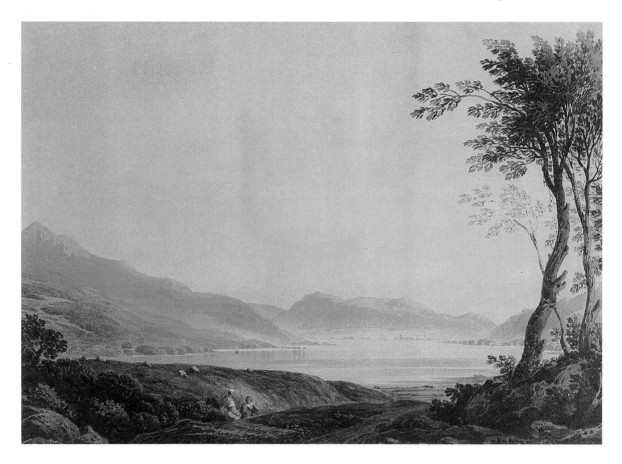

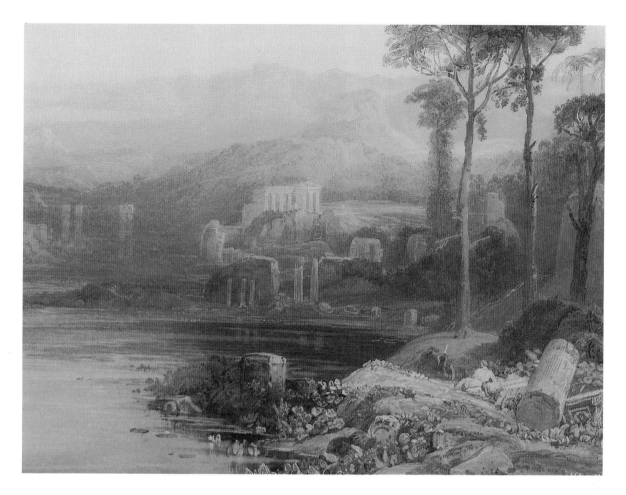

The impact of war

In 1799 the Napoleonic Wars broke out and Europe was closed to the British traveller. Artists were forced to turn to their native landscape, and the land itself became a subject rather than being a backdrop for portraiture. John Varley (1778–1842), Thomas Girtin (1775–1802), John Sell Cotman (1782–1842) and David Cox (1783–1859) ushered in the golden age of British watercolour, while Richard Parkes Bonington (1802–1828), William Callow (1812–1908) and, above all, Joseph Mallord William Turner (1775–1851) drew inspiration from the maritime tradition of the nation. Girtin and Turner in particular explored the capacity of watercolour for creating atmospheric effects, experimenting with texture and colour.

The art establishment continued to reject watercolour nevertheless, and in 1804 a group of watercolourists instigated an annual exhibition in

▲ CLASSICAL LANDSCAPE
Francis Oliver Finch (1802–1862)
55.5 × 75.5 cm (21¼ × 29¾ in)
Within this typically British landscape painting with the calmness of a horizontal composition there is a theatrical approach to a romanticized view of classical history.

London. No fewer than 11,000 people attended in the first year, and by 1809 visitor numbers had risen to 23,000. These paintings of landscapes that were still largely inaccessible to town-dwellers aroused enormous interest, and in 1881 the Society of Painters in Watercolour was granted a royal charter and subsequently became known as the Royal Watercolour Society. By this time Europe was available again to travellers such as Francis Oliver Finch (1802–1862) and Edward Lear (1812–1888), but the British had now taken watercolours of their own land to their hearts.

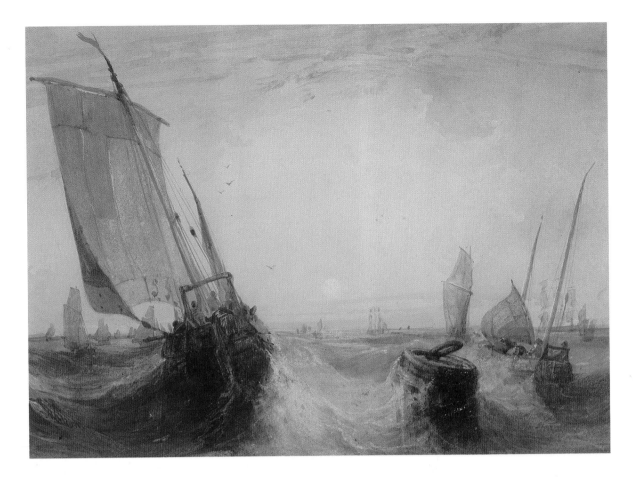

Into the 20th century

War has been a defining influence on British art, and artists such as Paul Nash (1889–1946) and Christopher Wynne Nevinson (1889–1946), who were sent to the trenches in the First World War as official war artists, demonstrated conclusively that watercolour was not limited to polite paintings of the landscape. The ease with which it could be transported made it ideal as a medium under such logistically difficult circumstances, and it proved that it was capable of expressing strong emotions. In the Second World War, Henry Moore (1898–1986) used watercolour in his sketches of the people of London wearily huddled in the underground stations while bombs rained down on the city.

In the 1950s polymer-based paints such as acrylics became available and art shops sprang up in every town. In the 1930s a sheet of handmade paper would not have been easy to acquire, but now there was a rapidly growing

▲ **SEASCAPE WITH SHIPPING**
William Callow (1812–1908)
17.5 × 25.5 cm (6⅞ × 10 in)
The diagonals of the masts give this otherwise simple composition a dynamism often encountered in seascapes. The adventurous use of scratching out in the foreground waves adds another layer of interest to the painting.

leisure industry and the market was there to serve it. The rise of adult education also had a big influence, with art classes easily available and fully booked both daytime and evening. Turner had been the first watercolourist to express equal interest in the surface quality of the medium and the subject itself, and his influence was still felt – but now there were new pigments and the liberating force of two world wars and the Cold War that succeeded them, which allowed artists to be even more expressive in their comment upon the world.

The present day

Watercolour is capable of saying something simply and beautifully because of its luminosity and the sensual quality that allows the viewer to enjoy the paint without even thinking about the subject. However, a greater range of materials allows us as artists to explore new ways of expressing ourselves on paper. While many of my favourite painters such as Richard Parkes Bonington, David Cox, Thomas Girtin and Turner are very much in the classical tradition, modern-day artists such as Jenny Wheatley (b.1959) and Leslie Worth (b.1923) are using admirably innovative ways of handling pigment. Although they still acknowledge watercolour as a means of portraying a subject, both of these artists are concerned with the handling of colour as an activity in its own right.

It is becoming more accepted that other water-based media can be a part of a watercolour painting if they are applied with a watercolour technique that complements rather than destroys the qualities of the medium, but this does not mean that the barriers are coming down on the traditional landscape. As watercolourists we are living in exciting times where the boundaries are disappearing and we can draw from both the old and the new. We have shaken off the pilgrim's burden of seeing ourselves purely as topographical landscape painters and recognized our medium as being capable of all sorts of emotional responses, and watercolour has finally taken its rightful place in the hierarchy of art.

▼ PASSAGE TO INDIA
Jenny Wheatley (b.1959)
58.5 × 94 cm (23 × 37 in)
In this large mixed-media painting the subject matter with all its exoticism is shown with the exuberant treatment and density of colour that has become associated with watercolour, now regarded as a strong and expressive painting technique.

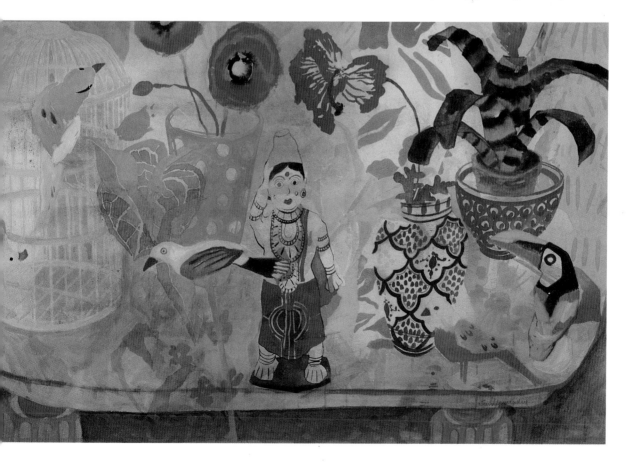

The scope of this book

In this book I hope to take you on a journey, some of it technical, some of it emotional, and all of it concerned with the excitement of watercolour painting.

Any work of art is a combination of three things – the subject matter, the materials and the temperament of the artist – but underlying that there must be some understanding of technique and how the pigment reacts when it is handled. The book contains chapters on materials, methods of laying down and lifting off paint, drawing, composition, tone and colour that will suggest exercises for you to do whether you are outdoors or painting at home. However, the emphasis throughout is on learning the practicalities of being expressive with watercolour by taking advantage of its unique qualities.

I travel widely in my work and many of my paintings are concerned with the quality of light in urban landscapes. A number of the paintings in this book are of subjects found in Italy, Spain and Czechoslovakia as well as in Britain, but you will find in them problems and answers that are pertinent to a painter in any setting. Some of them are of mundane places, but they speak of my involvement in the activity of painting. A picture is not always painted to create a finished product: more important is the learning experience each one offers, even to a professional artist.

▼ BOATS IN THE DOCKYARD
40.5 × 56 cm (16 × 22 in)
This painting is concerned with line, tone, colour and composition, but above all with an expressive feel not only for the technicalities but also for that sense of time and place.

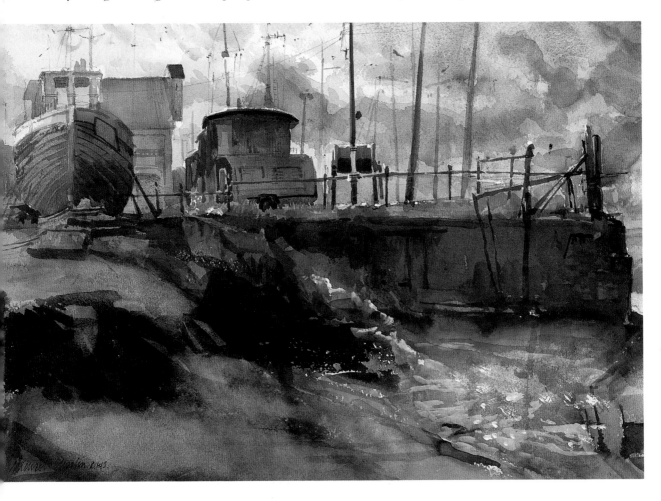

The freedom of painting

Most tribal societies have painting as a part of their culture, with the ability to decorate their own house, paint directly on their walls and comment on their own personalities within their own spaces. Unfortunately, in the West we have largely sidelined painting into something academic or commercial and there are too many people who go to galleries and say, 'I wish I could do this myself', without realizing that they can.

From an early age it is a naturally expressive action to pick up paints and describe your life – house, garden, mum and dad, the sky, the family pet. However, along come self-consciousness and the fear of failure, the need to find a job, raise a family and keep a roof over their heads, and art is put aside. When you begin to paint again as an

▲ MYSTRAS, GREECE

35.5 × 51 cm (14 × 20 in)

For me the joy of painting is apparent in a picture like this: the excitement of new places, the study of new things and the sense of magic when subject and medium work together. That sense of magic is a permanent reminder that with painting one is always a student.

adult, anxiety about technique can sometimes take precedence over your ability to respond emotionally to your subject. There is certainly a pain barrier of learning the rules to be worked through, but my hope is that this book will help you to the other side and give you the tools with which to rediscover your long-lost freedom to express yourself in paint.

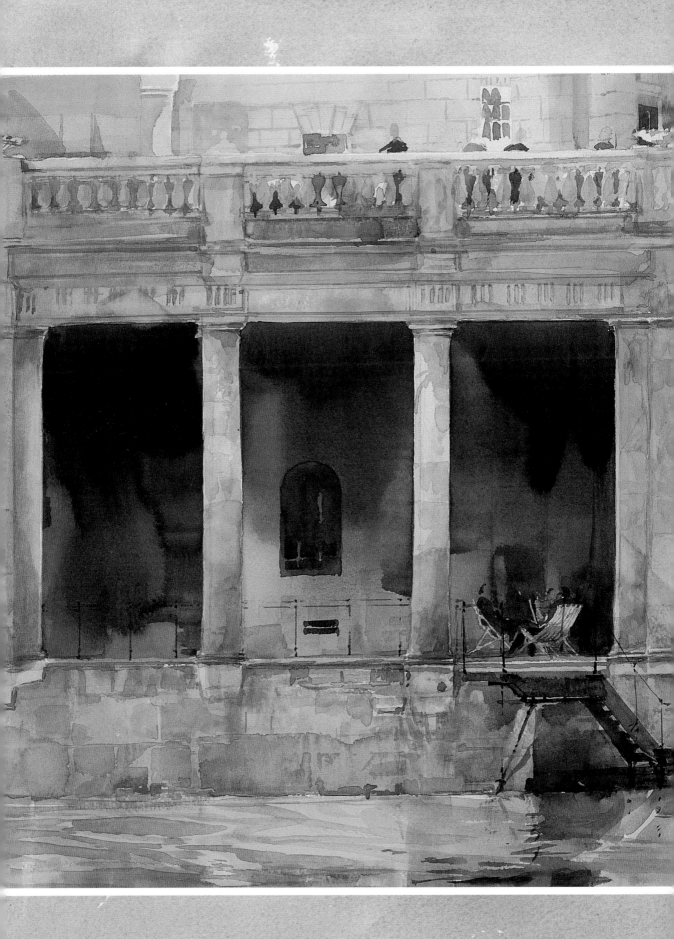

Materials and Equipment

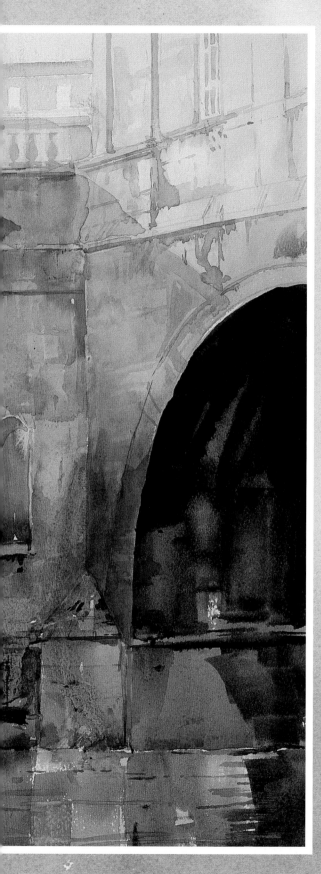

Materials and equipment can be as simple or as complex as you care to make them. While it is good to have the tools that are right for the job, spending a lot of money is no guarantee of success and sometimes the best paintings are done with only basic equipment. Gradually accumulating tools as you need them is the sensible approach.

◀ **PULTENEY BRIDGE, BATH**
45.5 × 58.5 cm (18 × 23 in)
This elegant façade presented me with the chance to employ classical techniques of loose, subtle washes backed up with minimal drawing. The size of this painting made it more easily done as a studio piece.

Paints

With paints, you really do get what you pay for. There are ways to save money on equipment (see pages 22–3), but using student quality rather than artist's quality paints is a false economy. The latter are much more luminous and as the colour is far stronger you get greater covering power, making the difference in price less than it appears to be.

There is not much to choose between the cost of paint in pans or tubes. Pans are more useful for travelling and although half pans and full pans are the most commonly found, you can also buy quarter pans if weight is a problem and you do not expect to use large amounts. I use 15 ml tubes in the studio but when I am away from home I duplicate the favourite colours in my box with 5 ml tubes which can be left behind at the hotel. If the paint in the pans is running low I just squirt some more from the tube into the pans. Within an hour or two a skin forms on top and I can safely fold up the box and put it in my pocket for the next foray.

On tubes you will find information as to whether the colours are permanent or fugitive, but to discover whether paints are granulating, staining, opaque or transparent you will need to consult a manufacturer's chart. A printed one has limitations, and to see the true quality of the colours it is worth paying for a handpainted one. Most manufacturers supply these at a cost of about £5, a price you will probably save by purchasing exactly the right pigments.

A versatile palette

Red, blue and yellow are the basics, but ideally you should have cool and warm versions of each. Mixing a green from a cool blue and a hot yellow will make a muddy colour, as will mixing a greeny blue with a red to make a mauve, so provide yourself with sufficient pigments to mix subtle, fresh colours. Including a dark red and a dark blue will allow you to increase the tonal range.

My own basic palette, following these principles, consists of Cadmium Red, Magenta and Permanent Mauve; Lemon Yellow, Cadmium Yellow Deep and Raw Sienna; and Coeruleum, French Ultramarine and Indigo. Because I use a lot of dark colour I also add Burnt Umber, Ivory Black and Hooker's Green Dark.

◀ *I am a hoarder of paints, but you do not need this many and a superabundance can be a disadvantage. Build your collection slowly, adding to it only when you need to.*

Brushes

There is no specific set of brushes that will suit every artist; brushes are designed to do a particular job, so you will collect a range that are able to make the marks you want.

The best-quality brushes are made of kolinsky sable. Each hair from this animal is thin at the base, broadens out and then comes to a fine point, so a kolinsky sable brush naturally makes a bellied shape that can come almost to a single-hair point. It makes an excellent drawing tool because it will hold a lot of water, allowing you to work without frequently dipping into the palette with all the potential changes of tone and colour that could cause.

For dry brushwork skimmed across the surface of the paper, a stiff brush is useful. These tend to be made of synthetic fibres and they have the disadvantage that, because each hair is very smooth, when you touch the paper the paint tends to flood out of the brush much more quickly than from a hair brush, which has a slightly roughened surface. However, if you like to scrub paint on to give texture, a synthetic brush is cheap and more expendable than a kolinsky sable. The alternative is a brush that is a mixture of synthetic and hair, which has some of the flexibility and water-holding capacity of a sable but will stand much more vigorous use.

Brushes made of other animal hair do not have the springiness of a sable, but used vertically for laying large washes they are ideal; even shaving brushes and housepainter's brushes have their place, depending on the marks you wish to make.

Caring for your brushes

A good kolinsky sable is about £80, so you will want to look after your brushes properly. When you finish working, wash each brush out very thoroughly; if you leave pigment deep in the belly of the brush it will build up and the brush will lose all its resilience.

Washing removes the natural oils, so squeeze a small amount of hair conditioner into the palm

▲ *Most artists accumulate a large number of brushes. Although these are among my collection, in practice I use the same three brushes nearly all the time.*

of your hand and gently roll the brush around in it. Leave it for a few minutes then rinse well. Reshape the brush by hand, dry off excess moisture with a tissue and allow to dry upright in a well-ventilated area, preferably not in direct sunlight. If you are storing brushes long-term, put some mothballs with them.

FOCUS ON...
grinding paint

Making your own paint is a lot of work but it gives you complete control over how coarsely or finely it is ground, so if you are interested in granulated or textured paint it is ideal. The other big advantage is that you can have large amounts of paint in pots broad enough to get the widest hake into, which encourages you to think larger.

Pigments can sometimes be bought from an art supplies shop, but if your local shop does not stock them, ask for the address of an artist's colourman. Although most pigments are non-toxic there are a few that are dangerous; avoid inhaling any of them. Some can be irritant to the skin so, if you are susceptible, wear rubber gloves.

The main constituent of the binder is gum arabic, which exudes from the bark of the acacia tree. It is hygroscopic, which means that it absorbs water, so as a medium for making watercolour it performs two functions: it sticks the pigment to the paper but it will also reconstitute very readily as paint because it will attract water.

Gum arabic tends to dry out in the paint and is quite brittle, so the other main ingredient is

▼ Pigments
Pigments are supplied as dry powder in a bag, minimum amount 50 g (2 oz). The cost ranges from about £4 to £30 per 450 g (1 lb). The powder is very fine, so do not tip it out of the bag – lift it out carefully with a spoon or palette knife.

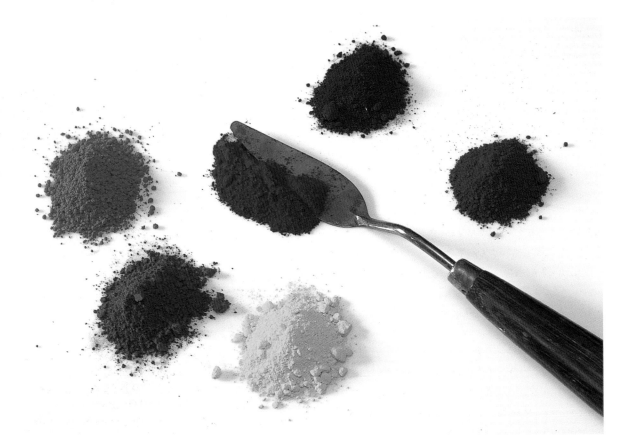

glycerine, which keeps the paint soluble. You can also use honey, which gives smoothness to the paint, in a 50:50 mix with the glycerine. This viscous mixture would be difficult to spread, so ox gall is added as a wetting agent. Finally, to prevent mould, you need some vinegar or oil of cloves.

Grinding the paint

It is difficult to find a recipe for grinding paint and you will learn mainly by experience, but my method is to use four parts of gum arabic to one part of glycerine or glycerine mixed with honey, with a few drops of ox gall and vinegar. You can either make a stock solution of all those ingredients and store it in a bottle, or make a pile of pigment and add the ingredients separately to it. The binder will keep indefinitely but it will thicken if there is air in the bottle, so as you progressively empty the bottle it is a good idea to add some marbles to replace the binder or to buy a 'concertina' storage container from a photographic shop that can be squeezed smaller.

To grind the paint, add just enough binder to the pigment to make a workable mix and incorporate it with a palette knife until you have a wet, creamy mixture. This will be very coarse, so the next step is to grind it with a muller on a slab or with a pestle in a mortar, adding enough water to make it workable. Although most tap water is pure enough to use, it is best to buy distilled water to make sure the colour is not affected.

In the case of colours such as Burnt Sienna and Burnt Umber which are natural earth pigments, albeit already sifted and pounded, you will be able to hear their grittiness and you will learn to judge by ear how coarsely or finely you have ground them. Grinding the paint generates quite a lot of heat and dries the mixture, so you will need to add more water as you go. When the paint is the consistency you want, you can use it immediately or store it for later.

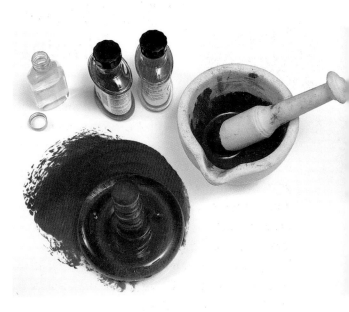

▲ **Grinding equipment**
A heavy glass muller, available from the supplier of the pigment, is used on a ground-glass slab. A cheaper alternative is a glass, earthenware or porcelain pestle and mortar, available from hardware shops. Do not use a wooden pestle as you will not obtain sufficient grinding power.

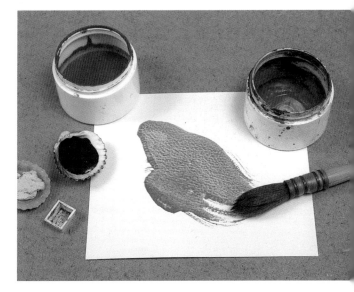

▲ **Storing**
Pigments can be stored in pots obtained from a pharmacist, in emptied pans from a paintbox or in shells – the traditional way to transport paint before tubes and pans were invented. The Cobalt Blue shown here is much more heavily granulated than you would find in a commercially bought form.

Paper

The prime concern when buying paper is that it will not change colour and darken as it ages, as this would drastically affect all the colour and tonal relationships of the painting. Cheaper papers made of wood pulp are suitable for drawing, but for your paintings you should always use acid-free papers. The best quality are handmade from cotton, but there are cheaper alternatives made of a mix of cotton and what is known as a woodfree ingredient – in fact, wood with the lignum that affects colour taken out.

Handmade paper is made one sheet at a time. The wet fibre is scooped on to a mesh in a mould and shaken to the extremities of the mould, which gives it a deckle edge. It is then interleaved between felt blankets and pressed several times to expel most of the water, in the process gaining its surface texture. Finally, it is laid on nylon netting and left for 4–5 days to dry. Less expensive mouldmade papers are made as a continuous strip and then trimmed into individual sheets.

On a handmade paper you can use either side, while a mouldmade paper has a 'felt' side to paint on with a 'mould' side on the reverse that has a slightly mechanical texture. If in doubt, look at the watermark; the side on which you can read it the right way round is the one to use.

The most popular weight of paper is 300 gsm (140 lb), and this will need to be stretched if you are planning to lay very wet washes; heavier paper will not require stretching. The correct way to stretch paper is to damp it with a sponge or run it lightly under a tap on one side until the water really soaks through. Lay it flat on your drawing board and allow it to expand to its largest dimensions, which will take 1–3 minutes, depending on the weight of the paper and how heavily sized it is. The paper will form ridges as it expands and you will need to lift it at one edge and drop it back down on the board, passing a sponge over it to flatten it again.

When it is fully expanded, lightly dry off a strip round the edge with a rag. Dampen four lengths of gumstrip so that they are tacky and place along each edge of the paper, burnishing them down with a fingernail. If necessary, put in staples every 10 cm (4 in) to reinforce the grip of the gumstrip while the paper dries drum-tight.

Care and storage

All watercolour paper contains size to give it strength. If you leave paper in a damp area the size will dissolve over the years and the paper will become as absorbent as blotting paper. Size is also damaged by washing-up liquid, even residual amounts in brushes. Store paper with silica crystals that will absorb any damp and do not allow the presence of mould in the same room, as the spores will find their way to your paper. Keep any strong chemicals such as acid elsewhere in the house.

▼ *A selection of paper lying on a beautiful wood and bronze handmade paper mould. If you see paper being sold at a bargain price, buy it – because it is a very labour-intensive product it will become more and more expensive.*

Drawing tools

Your first approach to a subject is normally made with a linear tool, and more often than not that tool is a pencil. Although they are simple and basic, pencils are important because they are a very familiar item with which you will feel comfortable and you will consequently go straight to the heart of the subject when you are making notes rather than worrying about handling the tool that you are using.

Pencils range from very hard to very soft. A hard one will record absolutely precise detail but will be no good for blocking in tone, while a soft one is wonderful for making energetic notes but will not give you accurate detail, so carry one of each with you when you are travelling. A 2B will hold a fine point for quite a long time, while a 6B will give you all the tonal range and expression you need. A charcoal pencil is a step beyond a very soft pencil but your sketch will then need fixing and if you are travelling this adds to your burden.

Many of the sketches in this book were done with a pen and watersoluble ink, which gives the opportunity to make a line drawing and then indicate tone by adding a little water. This is an ideal way of making notes in a sketchbook, but if it is exposed to light the ink fades quickly. When you want a lasting image, use Indian ink or permanent markers.

Ink can be applied with a variety of tools, ranging from traditional metal nibs to felt-tip

▼ Rather than buying every type of drawing tool that is on sale in your local art materials shop, gradually accumulate tools that suit your temperament, style of work and subject matter. This box, which I have had since I was a teenager, has filled up over the years with tools that are particularly suitable for me.

pens. The former are quite difficult to work with because you can pull them but not push them. Try cutting a point on a bamboo cane from the garden or on a quill – you will need to keep resharpening the point but you will get some pleasing splattery marks. With the quill, you also have the option of using the other end as a brush.

For colour notes, available drawing tools include watercolour pencils, oil pastels, chalk pastels and watercolour inks. The first are also useful if you want to put a drawing down that will not survive the washes in a finished painting. Be aware, though, that if you are using them for more permanent marks they will easily mix to a mud if you disturb them with a wet brush. Instead, give them a fine spray with a diffuser to wet the colour and make them spread without stirring them in together.

Outdoors and indoors

The materials and equipment that you use, and the circumstances in which you use them, do affect the look of an artwork. Consequently, you should always aim to make specific decisions about your media and accessories rather than just employing whatever is to hand. Out on location, you will have concerns about weight and ease of carrying, while at home there are issues of lighting and space to be resolved.

An outdoor kit

I have several small travelling bags hanging on a hook inside the studio door. The smallest is a pocket-sized bag which has a pencil, a fountain pen, a ballpoint pen and a little pad of white paper. It is purely about making very quick linear notes to use as an *aide-mémoire* later on. Another bag has a box of paints with a folding brush, a pot of water and a small camera, giving me the facility to make more complex notes about colour and tone while still being very light to carry. These two bags are for drawing on the hoof, looking at lots of subjects in anticipation that one or two might be worth returning to.

It is a mistake to set out every time with the expectation of doing a very formal painting as this imposes pressure upon you. Much of my working time is spent taking sparse notes to get a feel for the place and I might make several visits before I arrive with a kit that is the full works, with easel, stool and umbrella. By this time I will have formed a strong idea about composition, colour range and tonal range and I will be ready to go.

With this amount of equipment a car is more or less essential, but weight is still something to be considered. Lightweight foamboard covered with plastic on both sides is ideal for travelling. I take two sheets with the paper sandwiched in between to keep it flat, then use the two sheets together to make a rigid drawing board. I have a strip of Velcro on the back and a corresponding piece of Velcro on my lightweight easel, and this gives a solid structure. In the absence of an easel, the foamboard can simply be rested on the knee.

A bin liner is excellent emergency cover for both painting and materials if it rains. Equally mundane but useful are plastic trays such as party dip containers and airline plates, which make good palettes. In art shops you can buy a lightweight stool with a bag attached that is carried as a rucksack on your back – but you can find them much cheaper in a market, so shop around.

▼ *This is my typical painting bag. It is waterproof and contains a paintbox with 14 half pans, a water-carrier and minimal palettes. Also included are tissues, loose sheets of paper, a camera for recording detail and a selection of drawing tools.*

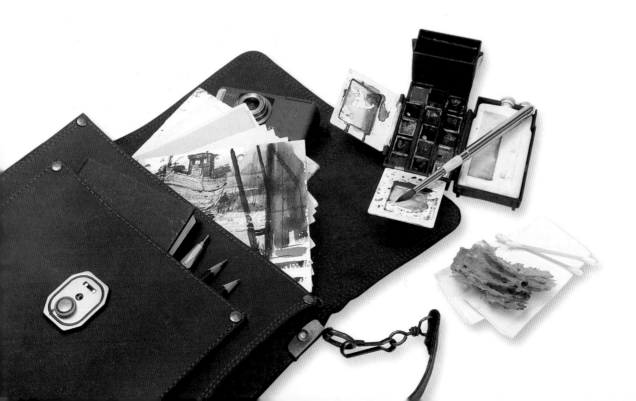

Working at home

Having the luxury of a studio is not given to everyone, but if you do have spare space in your home it is your good fortune that no one but you will want a north-facing room. North light is consistent and quite cool, and the colour balance will not change while you are painting. The disadvantage of a south-facing window is that you may get strong shadows moving over your painting, which is very disturbing. Try to put some sort of diffuser over the window, even if this is just a sheet of tracing paper, to avoid the sun causing very dark and very bright areas which make it difficult when you come to paint with colour and tone.

The light changes colour towards the end of the day, so as soon as you are aware it is getting dark turn the lights on. Do not rely on normal bulbs, which have a red bias to them that will affect the colours you are mixing. Invest in some daylight bulbs, which have quite cold blue light that emulates the north light – you should be

▲ In this photograph you can see part of the etching press in my studio. Ranged around are a variety of found objects such as the peacock feathers on the windowsill that I like to have in view simply for their interesting line, tone or colour.

able to find these in a craft shop. They are more expensive than ordinary bulbs but, given that you may paint in artificial light for half the year if you work during office hours, well worth the money.

Paint, paper and brushes will repay every penny you spend on them, but there is no need to pay art shop prices for other items such as drawing boards and sponges. MDF (medium density fibreboard), available from a DIY shop, is perfectly adequate for a drawing board if you roughen the surface with sandpaper, as is Formica – but beware of using wood that may stain your wet paper. With a supply of cheap boards you will be able to spend time stretching numerous sheets of paper which can be stacked up ready for days when you are itching to paint.

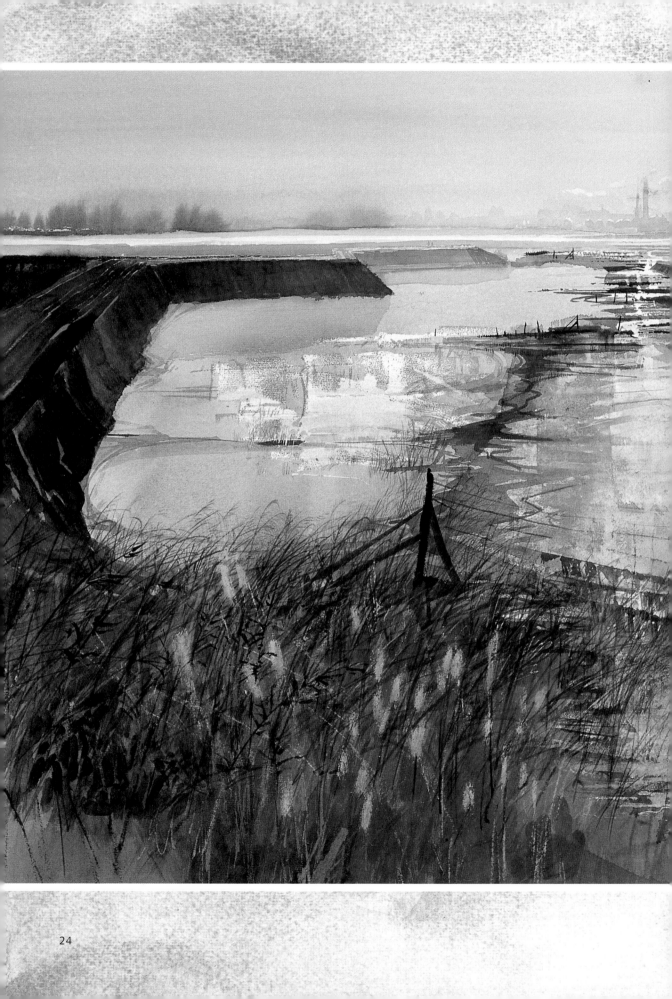

Techniques

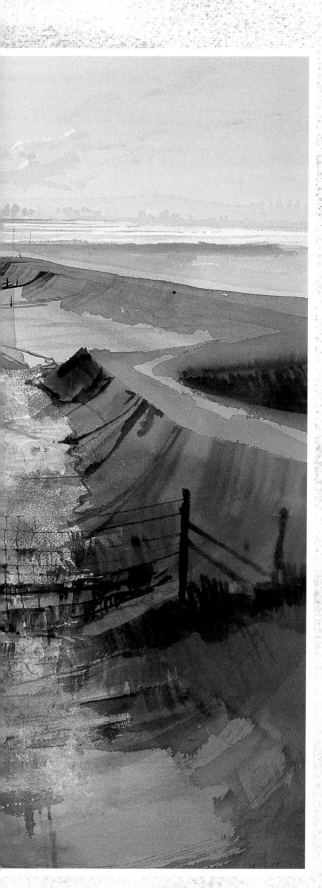

However excited you are at the prospect of making a painting that says important things about your subject, you have to begin by considering how you are going to approach it technically. This chapter offers advice about handling watercolour and other associated media that will give you plenty of choice as to how you express your feelings through paint.

◀ **SHEPPEY MARSHES**
66 × 96.5 cm (26 × 38 in)
Contrary to popular belief, watercolour is a medium you can manipulate in a number of ways and this large painting gave me plenty of scope. The paint has been put down, lifted back and reworked using a variety of techniques.

Putting down paint

Once you have chosen your subject and made decisions about size, format and colour range it is time for those first attempts at putting down paint. Nothing is more daunting to the artist than an immaculate sheet of clean paper, and your first washes will ease you into the painting process and give you confidence as well as laying the basis of your picture.

Whether you are working from a pencil drawing or going in fresh, your first colours will probably be concerned with covering quite large, loose-edged areas. The most obvious way of achieving these first washes is to use large brushes, for which you will need to mix up plenty of paint. Experience will tell you how much, but if you are not yet sure of quantity the best rule is to prepare a good deal more than you think you will require. For these big washes it is a good idea to add a few drops of ox gall to the mixing water to improve flow and increase drying time, allowing you a longer period in which to work with the wet paint.

The usual advice is to use white, preferably porcelain, palettes for mixing colours, but if you are working on tinted paper it makes more sense to use a palette that is roughly the same colour and tone as the paper. Seen against a white palette, the paint will appear very different from how it will look once laid down.

▼ **SHEPPEY MARSHES** (detail)
Here classical washes were laid very fast with plenty of water and ox gall. The less you fiddle with washes the more translucent they will be.

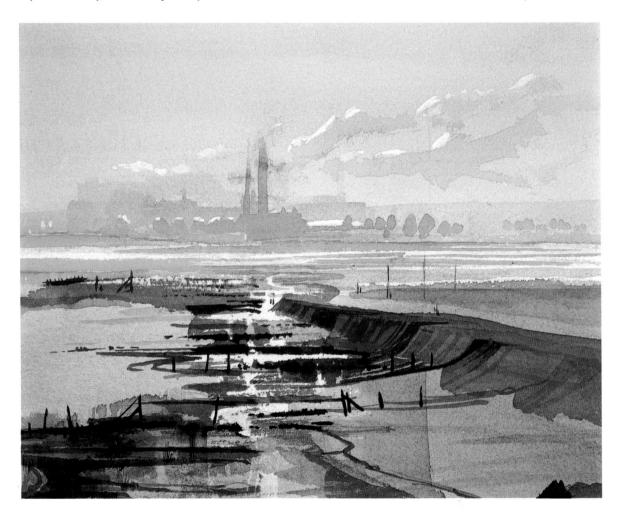

▲ *Here Cobalt Blue on a textured paper has granulated to give depth to the surface. Plenty of water and an angled board have aided the process.*

▲ *Scratching the paper with a blade has roughened and exposed the fibres, making them absorb more paint which then dries darker.*

Adding texture

Brushes tend to leave quite a flat deposit of colour, especially if the paint dries fast. Manipulating paint while it is still wet by pressing and blotting it with a variety of materials such as polythene, fabric or a sponge will give texture to your washes. You can also pull string or grasses through the paint for more linear marks.

The addition of gum arabic will increase the viscosity of paint and will make this easier – the paint will be thicker on the surface and will not sink in as quickly so you will get much more time to manipulate it. Do not make it too thick, however, or it will tend to crack when dry. Try out different textures on scraps of paper so

that you feel confident when applying these techniques to finished paintings.

Experiment with different types of brushes: I use a shaving brush for doing big washes as it holds a lot of water. Splattering paint by running your thumb over a loaded toothbrush gives a random speckled effect and you can also spray the paint on to the paper, using a sprayer for silk painting from a craft shop or a throat spray from a chemist, for a finer, more uniform texture.

◀ *Splattering with a brush such as a toothbrush, either into damp paint for a soft texture or into dry for a harder edge, will give good foreground texture.*

Lifting off paint

There is a belief that, unlike oil paint, once watercolour paint touches a surface it stays there. This is far from the truth, but the type of pigment is a major factor in whether it can be lifted off or not: some (usually the organic pigments) are only lightly stuck to the surface by gum arabic binder, while others (which tend to be more synthetic colours) enter and dye the fabric of the paper. A good colour chart, available from the manufacturer, will tell you which colours are staining.

Synthetic colours can be made easier to remove by adding more gum arabic, but they can never be completely lifted out to reveal white paper. The organic colours are much simpler to deal with, particularly when they are freshly laid down. Wet the surface with a brush and allow 30 seconds for the paint to reactivate, meanwhile washing your brush in clean water and wringing it out well so that it is slightly moist. Pass the brush over the area and the capillary action of the wet paint will mean it is sucked straight up into the brush. You can also use a sponge or tissues to lift out.

Rewetting a wash by spraying it with a diffuser allows you to lift out without disturbing the general characteristics of the wash, such as one with blended colours or tones, which would be destroyed by wetting it with a brush.

▼ **SHEPPEY MARSHES** (detail)
The dark area in the foreground has been dampened and lifted with a brush, while the light on the far shore has been pulled out with the flat of a blade.

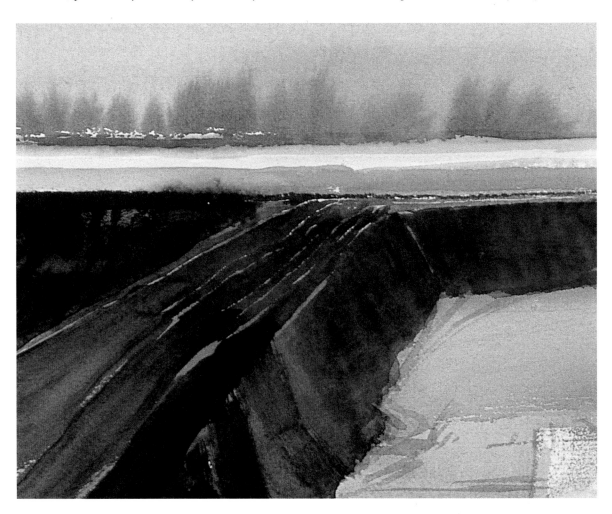

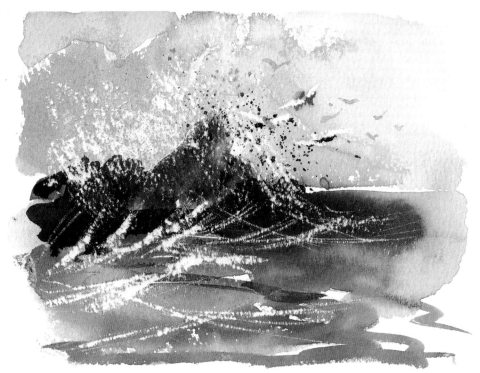

◀ *Scratching with a blade was a direct way of putting the white of breaking spray into this example. If you do not damage the paper too much you can reintroduce colour into scratches.*

Taking advantage of the paper

Paper is more than just a convenient support – it really does have an effect on how you are able to manipulate your paint. Heavily sized paper will keep the paint on the surface while a light size will allow it to be absorbed into the paper, and the more open the texture of that paper the more paint will cling on.

Scratching back to the paper with a blade has always been a convenient way of introducing whites and texture back into paint and is very useful if those whites would be impossible to work around when laying washes or if you do not want the hard edge that masking will give. Try experimenting with other apparently rough, almost sculptural techniques such as scratching and using sandpaper – surprisingly, they often produce the greatest subtlety and texture.

Never throw away pleasing visual effects, even if the painting as a whole was not a success. Cut them out and staple them in a small book with a written description of how they occurred.

▼ *Polishing a wash on rough paper with medium sandpaper gives an effect of sparkly light as the texture of the paper is revealed.*

▼ *Dampened paint will lift off easily after a few moments. Capillary action will cause the wet marks to be sucked into a clean moistened brush.*

Using masks and resists

In pure watercolour we do not generally have the ability to put light over dark because the colour below will leach through and affect the lighter one above, so we tend to reserve or work round light areas by painting the darker shapes at their borders. This can make it difficult to paint quick textured washes fluently round complex lighter-coloured shapes. One answer is to use masks to put a temporary barrier on the paper to stop the paint touching it.

The best-known barrier is masking fluid This is a temporary latex resist put down by a brush, stick, cotton bud or quill to make the mark you want. If you are using a brush, choose an inexpensive one and fill it full of washing-up liquid before dipping it in the masking fluid.

This will give you all the flexibility and drawing qualities of the brush without the masking fluid reaching the inside and ruining it.

Open-weave paper with coarse fibres and lightly sized papers may tear when you rub away the dried masking fluid. Rather than risk damaging a painting, test your papers to discover which will withstand its use.

Many painters use masking fluid coloured quite a strong yellow that visually affects all the other colours. A white one is preferable and you can now obtain one that is permanent so that you do not have to rub it off.

▼ **SHEPPEY MARSHES** (detail)
Soft pastels were used for the ephemeral, plumy flowerheads of the rushes. Further washes were then laid swiftly over them.

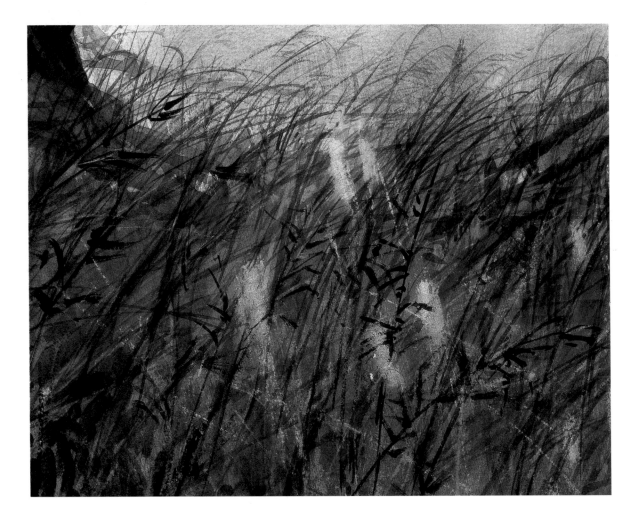

▲ *The light ridges on the shell were masked with an ordinary candle before the wash was applied. The horizontal marks were scratched in with a pen.*

▲ *Any grease will resist watercolour paints, but do consider the long-term effects on the paper. Here I applied a little petroleum jelly with my fingers.*

Exploring and experimenting

Masking fluid gives a hard, defined edge, and when I want to produce a very soft, amorphous shape I turn to chalk pastels instead. They also give the benefit of colour. This is a method I discovered for myself and it requires very fast and confident treatment, but have a go and see how it works – it is the only way to learn new techniques.

More conventional resists include wax-based media, from household candles to oil pastels. For convenience when travelling I use a white chinagraph pencil which is a very handy way of making little notes about white areas that will resist ink in pen and wash studies.

For hard-edged shapes adhesive tape can be used as a mask, but if applied straight from the roll it will tear the paper when you take it off. In order to avoid this, cut off a strip, hold it taut and rub it on the edge of a table. This will remove

half the glue so that it will come away from the paper more easily.

Low-tack paper tape of 5 cm (2 in) width is available and this can be used for covering large areas. You can cut shapes into it with a scalpel or scratch into it. Burnish round the edge of the hole with your fingernail so that the paint does not creep underneath.

Simple cut or torn paper shapes can be laid on the paper and then splattered round to leave white shapes. For patterned effects, try splattering paint through materials such as chicken wire or just bundles of string or grass.

▶ *Oil pastels are a direct way of putting colour down while providing a mask as well. You can use really strong colours knowing that your subsequent washes will have no impact.*

FOCUS ON...
working with mixed media

Watercolour is a most versatile medium, capable of depicting the delicate fleeting image as well as large-scale, almost sculptural objects. Between these two extremes lies a whole range of styles, expressions and techniques. For us artists, it is part of the fun to find out where on this spectrum we are most at home. Using a variety of media may lead you to a discovery of a working technique that you particularly enjoy, so do not be constrained by the Victorian tradition of pure watercolour. Introducing charcoal, collage, oil-based media such as pastels and oils or opaque colour such as gouache and acrylics to your paintings can add very particular marks to your work and increase your expressive vocabulary.

▼ **SUNSET ON THE DOWNS** 40.5 × 61 cm (16 × 24 in)

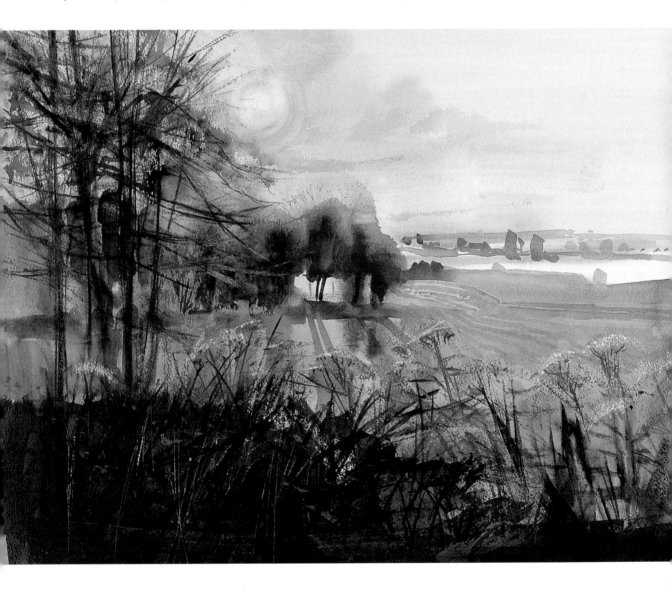

▲ Squeegeed acrylic

Ready-mixed acrylic was poured from its bottle on to the paper and spread with a homemade card squeegee. Try using a credit card or a comb for different results, or add water for thinner colour.

▲ Printed linear effects

For linear effects, print with the edge of a card squeegee, experimenting with varying thicknesses of card and different media. You can also damage the edge of the card before applying the pigment to make a combed edge or use a piece of corrugated card for a more textured surface.

▲ Using charcoal with watercolour

Watercolour washes applied over unfixed charcoal will disturb the drawing and produce soft edges, while using fixative will give a harder edge to the drawing. The same effect can be gained with dry pastels.

▲ Working whites into the painting

There are two ways of working whites into a painting: using opaque colour which will be quite flat and will tend to advance visually or scratching back through the colour to reveal white paper. Both are shown here.

◀ Using oil pastel on watercolour

Oil pastel can be drawn on to acrylic or watercolour to give bright points of colour and will be very permanent. As it has great covering power, it gives you the ability to put lights over darks. Chalky dry pastels are an alternative, but they are less stable.

DEMONSTRATION

The sunken pond

I liked the contradiction of breaking the format of this painting in two horizontally, the top half containing mainly verticals and the bottom half consisting mostly of horizontals with the subtle reflections of the verticals within them. There is a double narrative of the two painters absorbed in their work (in fact, students in one of my painting classes) and the lesser story of the fish indicated loosely in the foreground water.

Palette

| Cadmium Yellow | Cadmium Red | Burnt Sienna | Cobalt Blue | Permanent Mauve | Ivory Black |

Brushes No. 6 rigger · 45 mm (1¾ in) hake
No. 10 sable round

Cadmium Yellow blended with Ivory Black to make subtle green

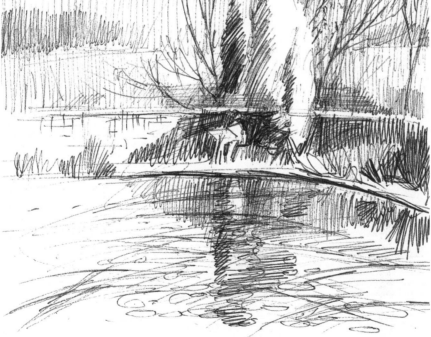

1 Drawing with a ballpoint pen is a relaxed approach, and I find it a good way to investigate the first steps. By using tinted paper I have made comments on tone from the very beginning and reduced the linear element. The main thrust of the compositional features that will appear in the finished painting has been established here. Although it is just a preliminary study I used watercolour paper to give me the opportunity to add colour if I wanted to.

2 I began the painting in my normal way by laying the drawing marks down with a brush and at the same time working the washes round those drawings. Using a hake gave me a good loose start as I was able to think both in areas and lines. The hake has been rocked gently from side to side to give the feeling of fishy ripples in the water. The middle bit was left absolutely clear so that I could achieve sparkly light on the top of the wall.

3 Next I established the main areas of light and dark, leaving the light on the top of the plant-hung stone wall and reserving the whites where the figures are with a No.10 round sable. I put in the mid-tone blue top on one figure so that I would know the tone I needed for the tree behind, which was painted with a mix of Ivory Black and Cadmium Yellow to produce a subtle mossy olive green.

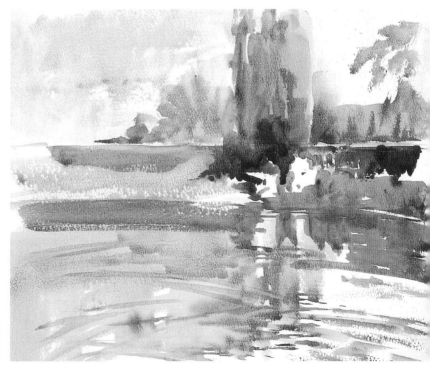

4 I introduced more colour into the figures and the flowers around them. Strong, hot points of Cadmium Red and Cadmium Yellow are starting to appear but as they are tonally very close to the wall behind they give those dark bits of the painting a lift without being invasive. They reduce in intensity towards the edges of the painting so that the eye is not drawn too far away from the focal point of the figures.

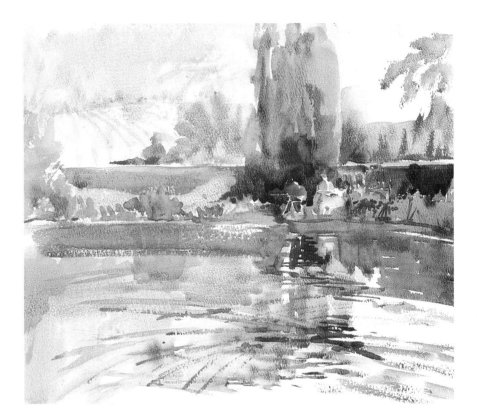

▶ I painted the reflections in the water and their source as one area of colour within the painting to give the colour composition some continuity. The more agitated the water the further reflections will travel downwards, so, as this water was disturbed by ripples from the fish in the foreground, I brought the reflections quite a long way down the painting.

▼ By now the colours and tones had reached their full strength – too much so in the face of the left-hand figure, which had become rather dark. Redamping the brush with clean water, I lifted out some of the colour in order to reduce the tone a little.

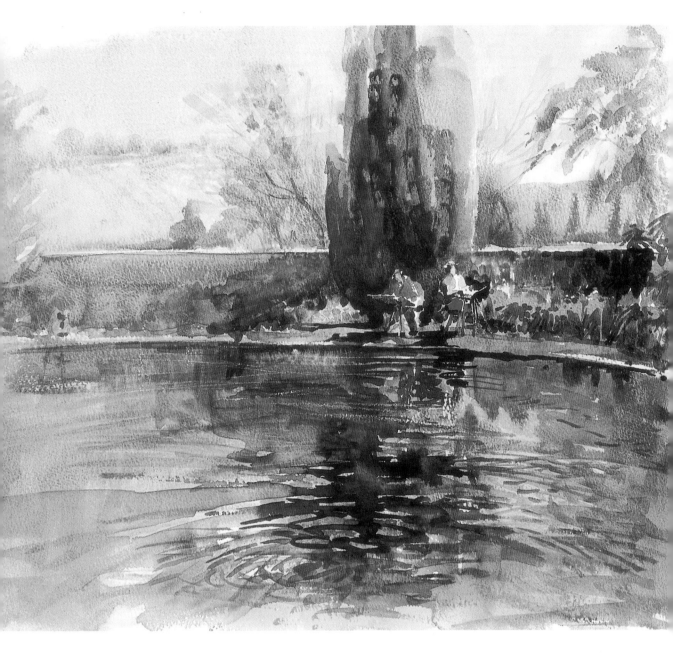

5 To finish the painting I put in more detail in the vicinity of the figures so that the eye wanders round that area. I did more work on the reflections beneath them and, using a craft knife, scratched highlights of tone there and in a rather dull area of water on the left of the painting. The fish were put in with four little marks of Cadmium Red with a touch of Burnt Sienna to mute it so that they are slightly hidden but warm enough to establish themselves in the foreground. I used a rigger to add the long, fluid strokes in the water and the branches of the trees.

▲ **PAINTING BY THE POND**
40.5 × 56 cm (16 × 22 in)
The composition of this painting is relatively simple but the colour is quite intense. The fish are merely hinted at, leaving the viewer to make the interpretation of loose slashes of paint, and work well as a colour note in the foreground.

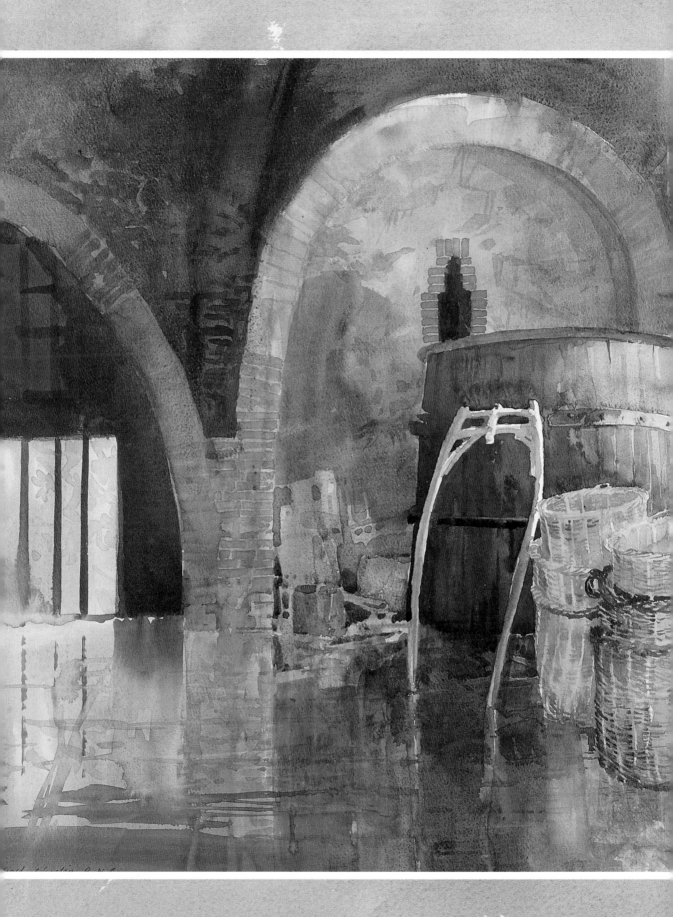

Finding Your Inspiration

Inspiration comes when you are least expecting it, but varying the opportunities you give yourself in finding subjects will certainly help it to arrive. Gardens, landscapes, cities, industrial subjects, interiors and domestic situations all offer possibilities. Just a simple incident, captured by a sketch, is enough to make an intriguing painting.

◀ CODORNIU DISTILLERY, BARCELONA
51 × 61 cm (20 × 24 in)
Warm colour, soft diffused light and sensual curves attracted me to this Spanish interior. The complexity of the woven baskets and the glowing floor reflections offered a temptation to overwork which I hope I resisted.

The mundane made magic

Because the history of watercolour in Britain is firmly based in landscape and architecture, we tend to approach the subject in a predictable way. Painting a farm nestling in rolling green fields from a polite distance with everything neatly framed within the format is the traditional approach, but not necessarily always the most interesting. Before setting up your easel, take some time to explore mentally the other ways you could treat the scene. If you move in much closer and take a thoughtful look at the surfaces of the stone and wood in the farmhouse you will probably discover a completely different picture to be done; older buildings carry a patina of colour and texture that transfers beautifully to a watercolour painting.

At the other extreme, the shiny glass façade of a modern city office block distorting and reflecting the buildings opposite produces very striking, almost abstract images. Unless you have been commissioned by the firm that owns it to produce a representational painting there is no reason at all to do a straightforward portrait of the building. Instead, you could concentrate on painting the patterns seen in a single window, which might include reflections of a river, the sky or a shiny red van parked alongside the pavement.

Everyday objects

For the artist there is always visual interest to be found in the ordinary. Do not ignore a subject just because you think it is mundane as within it there are all kinds of visual excitements to be found. It really does not matter whether the subject is mundane or exotic, as it is the way you deal with it that makes for an interesting painting. A trip to the supermarket to look for vegetables or fruit for a still life forces you to look at the produce laid out on the counters with a fresh eye. A crate of fish might seem an uninspiring sight, but you can find vigour, colour, textural interest or tonal drama in anything if you care to look for it.

Try keeping a box of found objects for future use. A seaside walk gains extra purpose if you take the chance to collect objects with interesting surfaces or colours, or perhaps the complexity of knotted rope and fishing net would make a good line drawing done on the spot. Regard everything as potential subject matter and you will never go short of an idea for a painting.

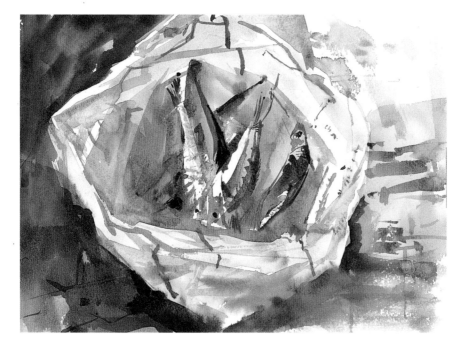

◀ SARDINES

25.5 × 31 cm (10 × 12 in)

Nothing could be more mundane than a plastic supermarket bag, but the pattern made from the green lines of the rolled-down sides makes a lively frame for the minimal brushwork that describes the fish within.

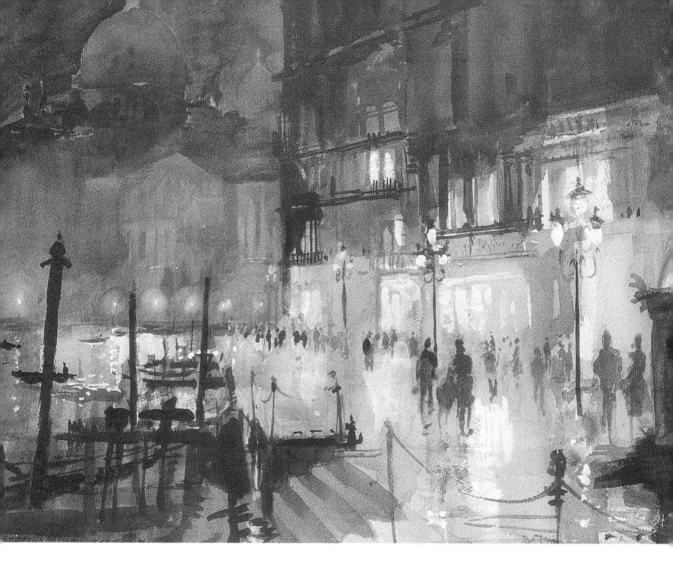

A time and place

Choosing different times of day to work can bring interesting insights to your painting. The long shadows of early morning and late evening can make interesting linear linking devices within a composition, while painting at night when colour has drained away and light patches shine within a dark painting can lead you to strong decisions about tone. The quiet stillness of an early morning has a special quality, with dew on foliage giving sparkling light. Try painting the same scene early and late in the day and notice how the cold blue shadows of the morning are replaced by warm, velvety tones in the evening.

The feeling of nostalgia is a strong human emotion. Walking through old walled gardens with the smell of clipped box hedge and sunlight shining through ripe gooseberries is among the

▲ **VENICE AT NIGHT**

38 × 51 cm (15 × 20 in)

The wet pavements of Venice on a rainy night captured the reflected light of street lamps and shops to make an atmospheric painting full of subtlety and mystery.

childhood memories I sometimes try to capture in a painting, but however seductive the subject I give at least equal importance to the business of painting – the balancing of line, tone and colour – rather than taking a purely illustrative approach. When drawing on nostalgia for inspiration the temptation is to try to describe all the objects as you see them in your mind's eye in your enthusiasm to communicate your memory to the viewer. The result will be a painting that has lost any sense of nostalgia and mystery because everything in it is so explained.

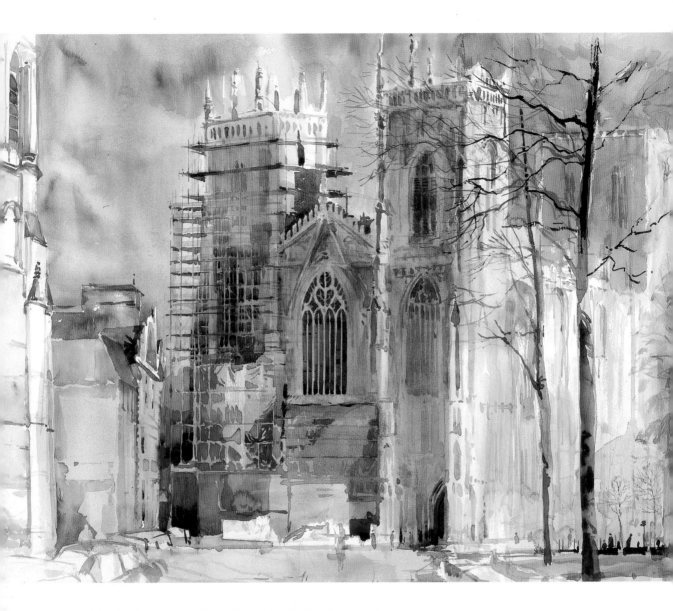

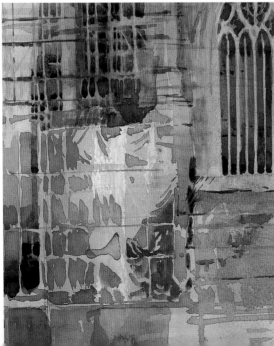

▲ YORK MINSTER

51 × 61 cm (20 × 24 in)

Though scaffolding may have defaced the appearance of the Minster for some, the way it echoed the Gothic architecture of the window was made for an artist to use in a painting.

◄ YORK MINSTER (detail)

The juxtaposition of the tarpaulin and window, visually two entirely different objects, made an interesting comparison in terms of design.

A sense of design

Art is usually an intuitive process and inspiration can come blindingly, but it is also a practical matter and all paintings have to be constructed from the first mark to the last. Consequently, some sense of direction is needed. You might adopt a simple plan, for example looking for repetitive elements in the composition using line, tone or colour to make for interesting comparisons, rather in the way that the melody might be repeated throughout a piece of music by different instruments. Alternatively, putting opposites together may make arresting relationships: try juxtaposing hard and soft, light and shade, textured and smooth areas.

Design is an instinctive human sense that varies from person to person. Looking for decorative elements in the subject and then executing quite a flat painting which is all about shapes side by side within a format might well suit your temperament instead of trying to give a picture an impression of three-dimensional space. Here design can be used in terms of flat pattern-making rather than in the sense of composition where we place real objects in relation to each other. But no matter what your style, inspirational thought must always be backed up by a concern for the design of the painting.

▼ **DRIED SEEDHEADS**
51 × 61 cm (20 × 24 in)
Playing off the soft texture of the onion seedheads against the hard, reflective qualities of the objects on the table was a gentle inspirational start to this painting of a domestic scene.

The intimate view

Any artist spends a lot of time just observing life and selecting moments of interest to comment upon. It is not necessarily the dramatic and important events that hold the attention the longest; quiet moments and small incidents make interesting subjects with a very human scale. To settle down with a sketchbook and a coffee and wait for the world to pass by is a bit like fishing – you never know when the subject is going to bite.

We all have a range of emotions from tender intimacy to anger and fear, and many of the finest paintings have dealt with these human feelings. Places as well can be redolent of nostalgia, quiet reflection, optimism or regret, and these are all subjects for the artist. Choose a moment to stop that will leave the viewer some work to do and thus involve them in the painting. If you explain too much your painting becomes a passing observation from the artist to the observer, and in the intimate view in particular you need to leave some mystery that will engage their attention.

▼ **THREE WAITERS IN PRAGUE**
28 × 35.5 cm (11 × 14 in)
Three waiters hovered attentively in a café in Prague. The moment was one of relaxed formality, with a minimum of painting in the crisp white tablecloths and the sumptuous Art Deco interior.

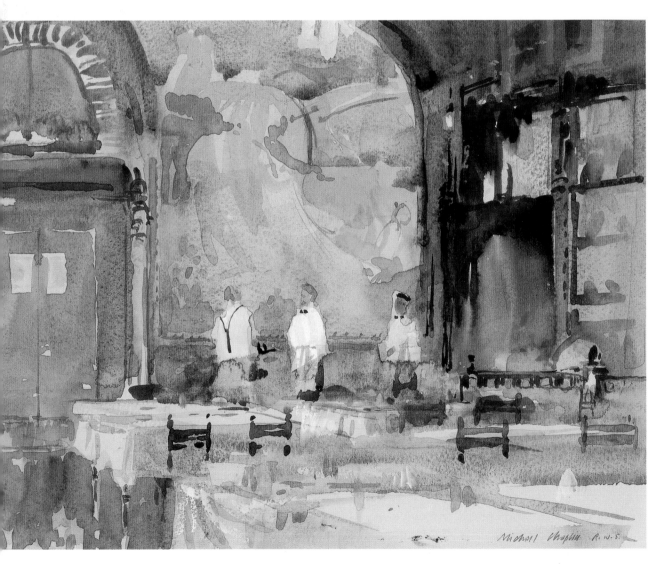

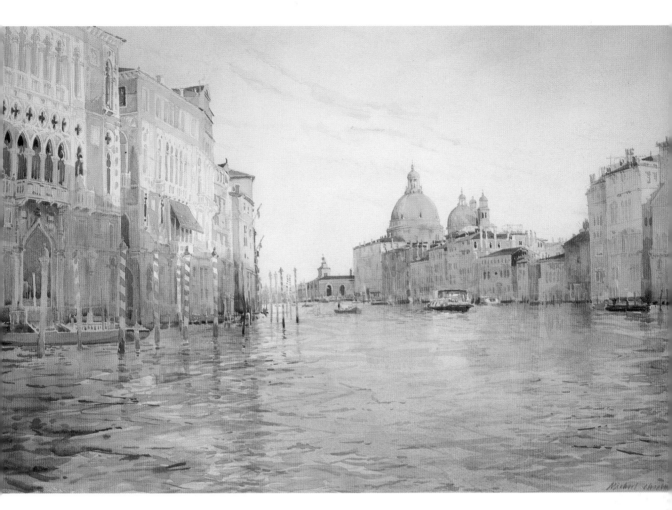

The grand scale

Some subjects just cry out to be dealt with in an entirely theatrical way, and this is often the case with monumental or classical architecture. Before beginning on a grand-scale work, consider the effect of size on a painting. Most subjects seem to have an appropriate size and it is not just a question of taking a sheet of paper from the packet and starting work. Neither can you assume that a grand-scale piece necessarily requires a large sheet of paper; a painting can have an imposing presence without being big. The scale is in the idea and the execution, not in the actual dimensions.

Size and scale being so relative, it is possible to make an area look large simply by including a small object, for example putting a boat on the sea. It is a common mistake to try to paint

▲ **THE GRAND CANAL, VENICE**
71 × 86.5 cm (28 × 34 in)
This is a big watercolour with large and complex washes. The sense of scale comes not only from the subject matter itself but also from the large area of water emphasized by the small boat.

spaciousness by leaving a large empty expanse, but if there is nothing to compare it with the scale is lost on the viewer. It is an invariable rule that a comparison will make the point.

Remember that paintings do have a life after the easel, and just as they have a right size in themselves they also tend to have a right place to hang. A grand-scale painting will need to fit its space, and if a large work is hung in a small room the viewer will not be able to get far enough away from it to see it as a whole and appreciate its scale and breadth.

The changing seasons

Taking advantage of all the different visual stimuli that the changing seasons offer has always made the artist's year one of variety and diverging influences. The linear complexity of winter, the fresh and clear light of spring, the full-volumed tones of summer colour and the subtle blending of autumnal tints are meat and drink to any artist as they remind us of the basic visual tools we have at our disposal. Working at the extremes of the year – late winter and early spring, late autumn and early winter – will give you a chance to paint sunrises and sunsets with spectacular silhouettes of naked trees against the sky as well as evocative cool misty mornings.

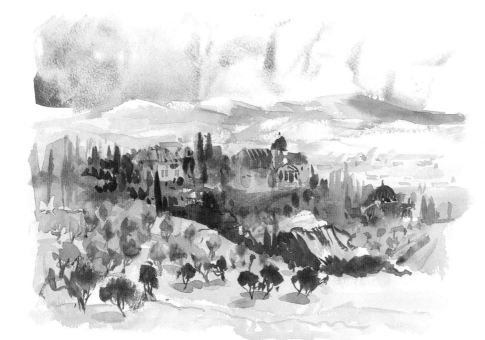

◀ **SPRING, GREECE**
20.5 × 25.5 cm (8 × 10 in)
This quick study was done directly from nature. The freshness of the handling equates with the feeling of spring regenerating.

▶ **SUMMER ON THE BEACH**
20.5 × 25.5 cm (8 × 10 in)
Full sun gives a richness to colour and tone which painters can react to with strong decisions of their own. Make sure the pans in your box are moist for the full benefit of the colour they can offer.

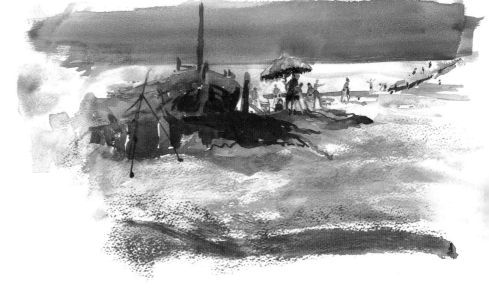

Practical considerations

No matter how inspired you feel, technical matters still raise their ugly heads. Spring is the easiest time to work because the light is good and paints dry quite slowly. In the heat of summer, try to find shade and if the light is blinding, wear sunglasses while you are drawing – but take them off when you are painting as they will alter all the colour and tone. Keep a small plant atomizer spray handy so that if the paint is drying too fast you can keep it moist by spraying it occasionally.

Winter has obvious difficulties, the main one being numbed fingers. The best solution is to keep a fisherman's handwarmer in your pocket. This is a small tin lined with fibreglass containing a charcoal stick that burns for about eight hours.

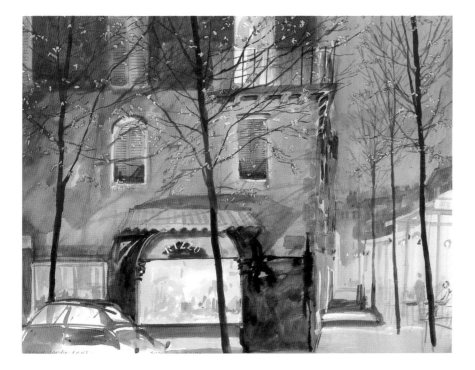

◀ AUTUMN, RIZZO
51 × 61 cm (20 × 24 in)
The subtle tints of the last autumn leaves were backlit by the shop window and gently echoed by the string of lights at the pavement café.

▶ WINTER: SNOW IN INNSBRUCK
35.5 × 51 cm (14 × 20 in)
Snow throws extremes of tone into sharp relief and including them in the buildings on the left emphasized the strange luminosity of the sky. This painting was done later in the studio from a small sketchbook study made on location and is a memory of a happy day travelling in Austria with my wife.

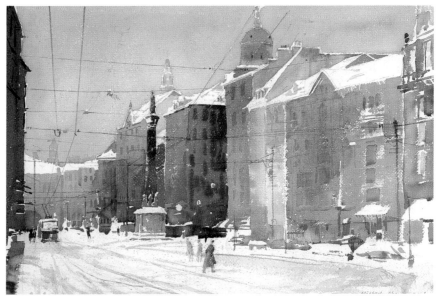

FOCUS ON...
using a camera for reference

There is a view that to use a camera as an aid to painting is somehow cheating, but no matter how accurately you can draw you will not always have time to record details in your sketchbook. Particularly when you are travelling, a small camera is an invaluable way to collect plenty of material for use in the studio.

Another advantage of taking photographs is that when looking through a viewfinder you automatically begin to compose a picture, which you can sometimes forget to do in a sketchbook. If you have a zoom lens it will encourage you to investigate small features within the broader panorama of your normal field of vision. However, remember that the camera can distort perspective and distance, particularly if you are using a zoom, and discrepancies will be amplified in a painting.

If your camera allows you control over focus, try taking some out-of-focus photographs where the subject takes second place to tones and colours. If your tonal studies are weak, spend a day taking black and white shots that will allow you to concentrate solely on tone.

Do not paint with a photograph right in front of you; pin it up at a distance that will give you a general idea of the weight of tones and colours. If you need to use detail you will have to walk over to it to pick up a bit of information selectively. Working in this way allows you to digest the information and make it your own.

▼ **The broad view**
This Tuscan hilltop village provides an obvious composition, but by moving in close with a camera it is possible to discover surprising subjects of both narrative and aesthetic interest.

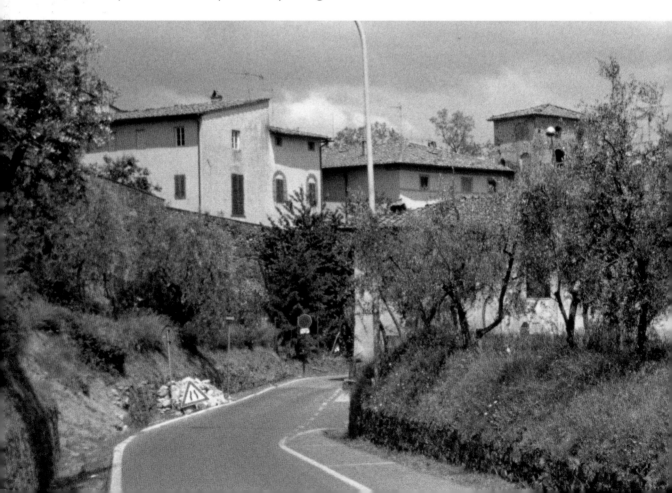

1

2

1 *Here stone and brick offer hot and cold colours, soft and hard edges and random shapes.*

2 *The relationship between these three primary colours is easier to see in a photograph than by eye.*

3 *The camera captured this dark figure against a light patch of wall, giving dramatic extremes of tone.*

4 *The bric-a-brac stall provided interest in the objects themselves and also in the linear patterns they cast.*

3

4

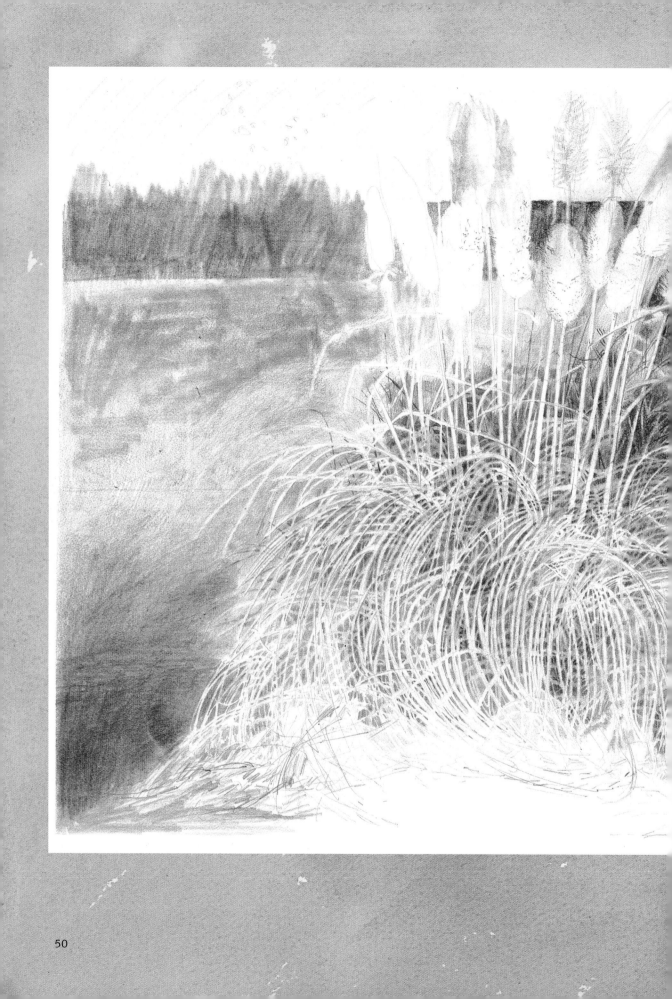

Drawing

When we draw we tend to use materials such as pencils and crayons that have been familiar ever since childhood and we are consequently very relaxed and instinctive with them. Because of this we often go straight to the heart of the matter and produce work of freshness and spontaneity that is much more than just a note-taking exercise.

◀ **PAMPAS GRASS**
45.5 × 61 cm (18 × 24 in)
This study of grasses in our garden became almost obsessive once I had constructed the initial drawing. Making the light areas appear by drawing the darker negative shapes in between them is relevant to watercolour technique.

First ideas

Initial drawings are normally made with what you have to hand but these first ideas, whether linear, tonal or colour, often determine how the painting will turn out. If you have only a pencil and sketchbook with you the thrust of that painting is likely to be about line and tone, whereas in fact it may have been the colour of the subject that attracted you in the first place. The best plan is to carry minimal materials that cover all eventualities, and a small range of watercolour pencils is invaluable. You can use them to draw with and also moisten the tips with a small brush to pick up a bit of colour. In effect, you will be carrying a very small palette of paints.

The format of the finished painting will probably also be governed by these first notes. Do not let the shape of your painting come by default; tear off additional sheets of your sketchbook and stick them together if the edge of your drawing needs to expand more.

The preliminary look at a subject is often just a thumbnail sketch to see if the idea is worth going on with. It is best not to spend much time on it or you may be reluctant to abandon the work you have done and persevere with a painting that should never have come into being at all.

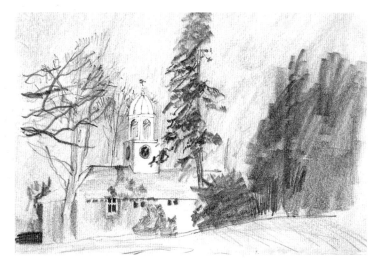

◀ CLOCK TOWER, MOTE PARK
10 × 15 cm (4 × 6 in)
In this pencil sketch the structured, orderly architecture of a classic clock tower is seen in all the evocative disorder of a neglected wood. My first thoughts were of the emotion of nostalgia but also the visual excitement of light and dark tones.

▶ COVERED SLIPWAY,
CHATHAM DOCKYARD

20.5 × 25.5 cm (8 × 10 in)
This strong, functional building was captured in a quick drawing by using materials that reflected its energy. Ink was applied with a piece of cut bamboo or cotton buds to identify hard and soft areas. The eye is held within the centre of the page by the crisper lines.

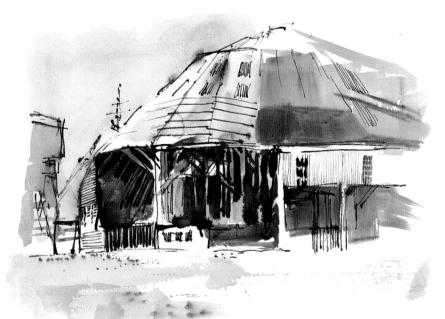

Objective and subjective drawing

The purpose of objective drawing is to record specific information about a subject, measuring from point to point, assessing angles and checking negative shapes for accuracy. If you lack confidence in your ability, attend a life-drawing class for six months; it will teach you accurate observation.

In subjective drawing, the artist impresses his or her own ideas upon the subject rather than making a straight photographic record, for example by exaggerating the horizontal lines of a landscape to give a feeling of serenity. The type of drawing you make is a matter of personal choice, and you may wish to do both to increase your options back in the studio.

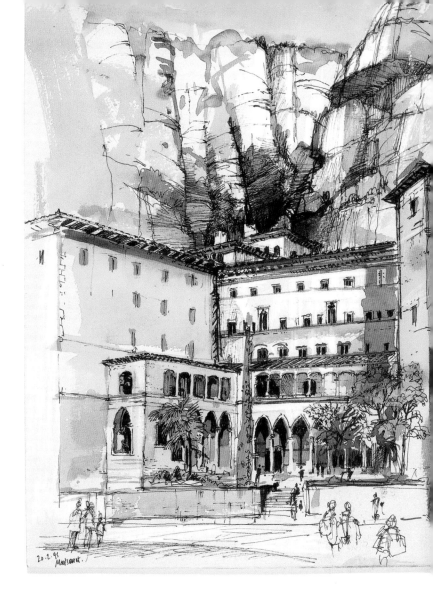

▶ MONSERRAT

28 × 20.5 cm (11 × 8 in)

This pen and ink study done on grey paper with some Chinese White to show light tones records detail in a very factual way. Notes on shadows are recorded, windows are counted, proportions are accurately measured.

◀ ALNWICK CASTLE

15 × 20.5 cm (6 × 8 in)

In this subjective monochrome study, done quickly with a brush and different tones of Burnt Sienna, I was attempting to discover whether the warm colour would make the subject seem more intimate.

Responding to the subject

Each of us responds most strongly to particular elements of a painting – colour, line, tone or texture. Unfortunately most subjects contain all these, so you will need to consider them all when collecting information. A line drawing will describe narrative and the size and position of shapes; a tonal study will provide atmosphere and describe volume and form; and colour notes will indicate the palette you will need. An arrow on the sketch to show the angle of the light is also useful.

◀ **ALNWICK CASTLE**
10 × 15 cm (4 × 6 in)
The dark and light tones share equal weight and space in this quick emotional study, drawn with a 6B pencil. This balance gives the chance to make a painting about light with some strong darks or vice versa.

◀ **ALNWICK CASTLE**
10 × 15 cm (4 × 6 in)
This line drawing, done with a fountain pen, records details of texture, character and action. The figure at bottom left gives scale to the composition. The two sketches together give all the information needed about line and tone.

Straight into paint

Drawing directly from the subject using brush and paint often provides a spontaneity that is lost when reworking in the studio. All you need to carry is some folding pocket brushes and a folding paintbox with about nine colours. Keep your sketches small, simple and as fast as your drawing skills allow.

Drawing with paint will lead you into colour in a relaxed fashion. Many people, having done a pen or pencil drawing happily enough, become inhibited at the prospect of picking up a brush and pigments and beginning upon a painting proper, whereas a paint sketch makes the transition far less daunting.

▼ TEA IN GREECE
15 × 15 cm (6 × 6 in)
This study in paint with no preliminary drawing catches a moment of sunny relaxation. Minimal detail and a light touch provide a sketch with an immediacy that may not be bettered in the studio.

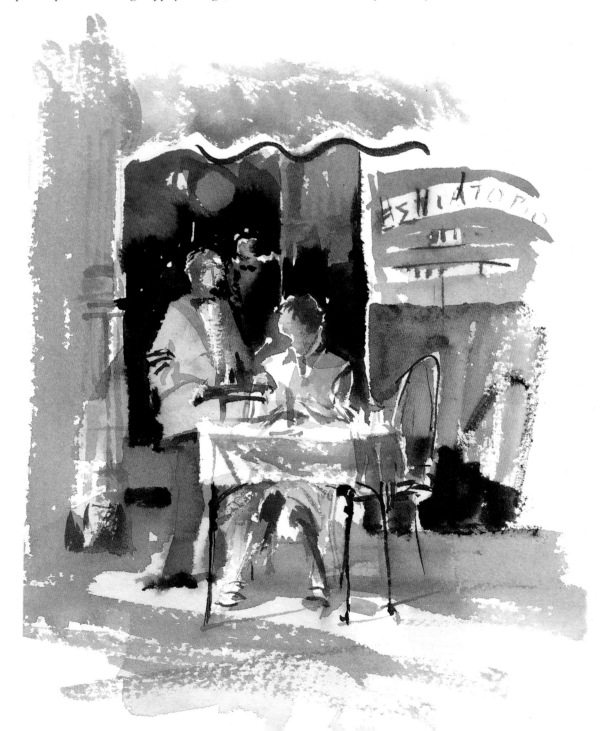

FOCUS ON...
bringing it all together

When you return home with some promising sketches, do not feel you have to work them up into a finished painting straightaway; you will often produce a better result if you put them away and come back to them several weeks or months later. Once you have done the initial drawings the ideas will still be in your head and if they are left to gestate for a while you are more likely to be imaginative with the composition and add some elements of your own. Where a painting is done immediately there is a tendency to be too respectful to the subject and the work becomes rather stiff and impersonal.

When you are ready to begin the painting there are decisions to be made about media, paper, format and composition. These are best arrived at with the help of some quick studies.

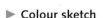

◀ **Sketchbook drawing**
In the sketch done on site I used a fountain pen with soluble ink and then a wash of clean water to provide a reminder of where the basic tonal areas were. This study has the bones of an interesting composition.

▶ **Colour sketch**
This colour sketch was done quickly on hand-made paper using felt-tip pens. It shows my first thoughts about colour and my intention to strengthen and simplify the composition, but I felt it had now become a little cramped and claustrophobic.

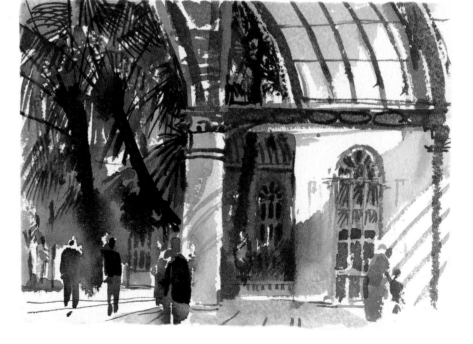

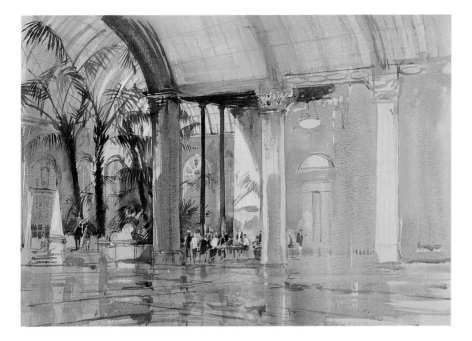

◀ **Watercolour with charcoal**
Working on a larger sheet of paper, I gave more space to the foreground with its interesting perspective on the shiny floor.

▼ THE PALM COURT, ALEXANDRA PALACE
51 x 71 cm (20 x 28 in)
The final painting has brought together many of the elements of the previous studies. Some have been omitted but the sense of spaciousness is still there.

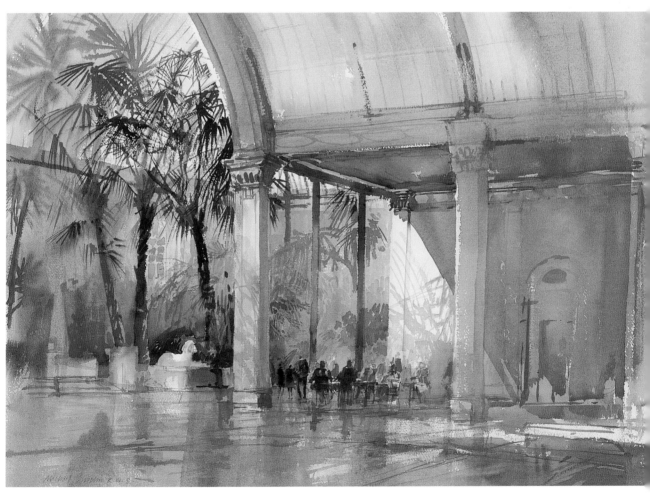

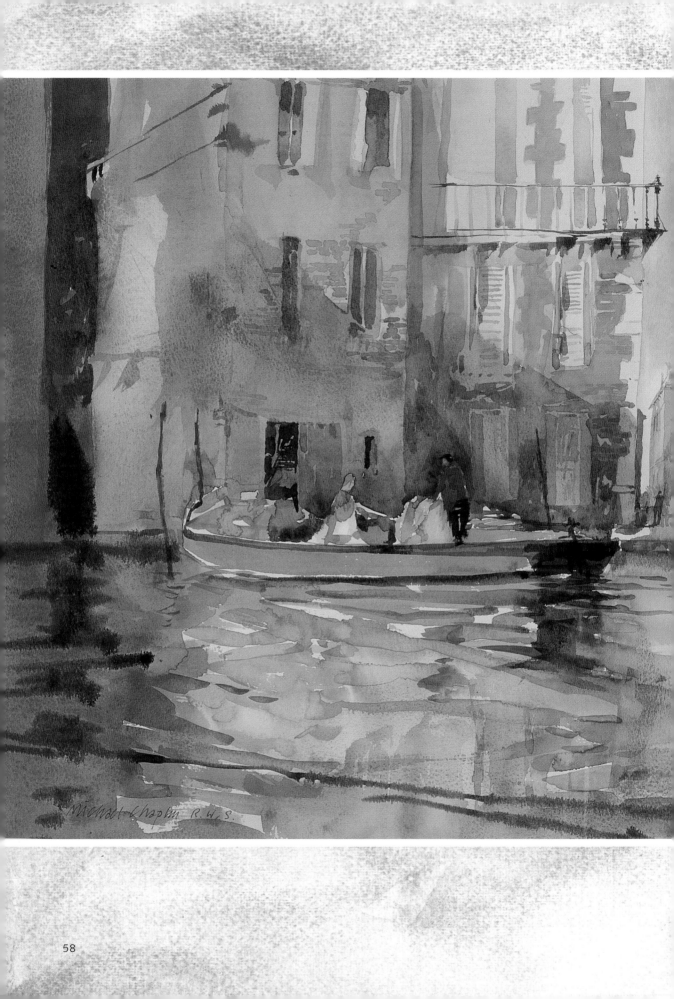

Tone and Colour

Because tone and colour are often studied as two different subjects it is all too easy to forget that when we are painting we are dealing with both at once. Colour must have tone and, drawings apart, tone usually means the shade of a colour. The trick is to make them complement each other in their contribution to a painting.

◀ BEHIND THE HOTEL, VENICE
45.5 × 56 cm (18 × 22 in)
This painting is very much about colour, with the darker colours leading the eye to the strongest colour accents. The dark vertical on the left and the diagonal line bottom left are a framing device for the strong colour on the boat.

Manipulating colour

Colour by its very nature has tone – the two elements are inextricably linked. However, a painting can be almost entirely about colour or, conversely, be based upon extremes of tone.

When you paint a colour-based picture, keep line and texture loose and simple so that the viewer's attention is not distracted from the colour. You can work within such a narrow tonal range that if it were photographed in black and white the image would be only a grey slab; the painting relies on colour for its effect.

It is possible to manipulate the tonal element of colour in very subtle ways. A mid-tone can be made to look dark by putting it against a light one, while a light tone appears much brighter next to a dark tone; no colour has a specific tone until it is seen in relation to another. This means that gradating tone in a sky behind buildings, for example, will in turn affect their colour and tone.

Watercolour paintings tend to be quite small, and colours can look frighteningly strong on the paper when you are putting them down. Remember that the transparent pigments will be two or three tones lighter when they dry. Opaque ones remain closer to the tone they have when wet.

▼ CORINTH

48.5 × 66 cm (19 × 26 in)

In this painting the sky changes from dark on the left to light on the right, and the opposite occurs on the entablature on top of the columns. This use of tone makes the colour more glowing.

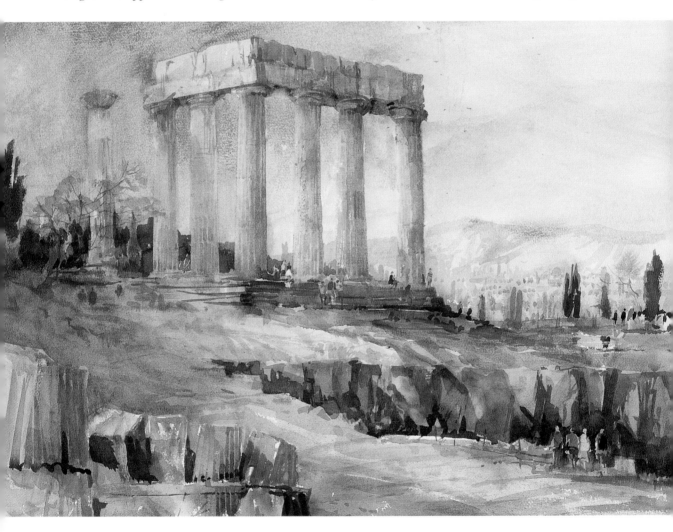

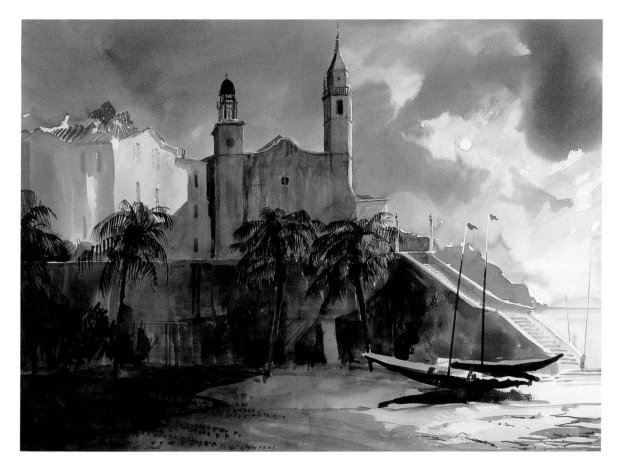

Handling dark tones

In a tonal painting you will want the ability to achieve dark, recessive tones. Adding black to a colour will make it dark but it will also be flat and opaque, with the result that it will come forward rather than allowing the eye into the picture. The answer is to mix two dark colours from opposite sides of the colour wheel. Hooker's Green Dark mixed with Permanent Mauve, for example, will give you a tone so dark that it is almost black but it will recede because it is still transparent. In a landscape, the result will be mysterious, remote areas that invite the viewer into the picture.

In tonally dark areas, adding one or two spots of hot or acidic colour will give the eye something to dwell on. If these highlights are the same tone as the surrounding colour they will tend to mix in with it, so if you want them to have real impact make them tonally different. Either the subtle or

▲ **SITGES**

48.5 × 66 cm (19 × 26 in)

Here the light was almost completely in front of me, so there are extremes of tone with some areas reflecting a lot of light while the darker areas are in silhouette. To avoid the latter being dead and uninteresting I put in some patches of acidic red, green and pink within the tonal range.

the more dramatic approach is equally valid, depending on the effect you want to achieve.

Dark tones can be a problem with watercolour: by its very nature water is required to make the paint fluid but its addition reduces the tonal characteristic of the paint, especially when you are laying large washes that require a lot of water. Large areas of tone will also look paler than a small dab of the same tone. Another point to bear in mind is that if you are working wet-into-wet, testing the mix on dry paper will not give you the tone it will have when dropped into a wet wash.

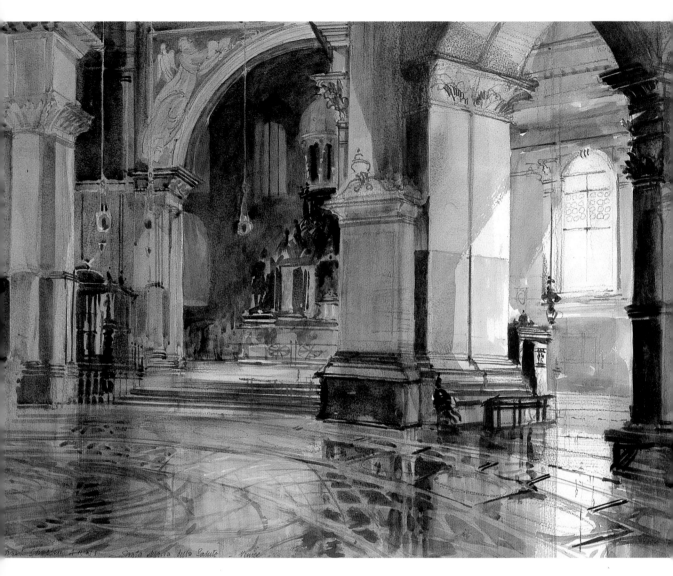

The drama of tone

Of all the characteristics a painting possesses –
line, tone, colour and composition – it is tone
that always makes the impact from a crowded
gallery wall. It is the sense of light and shade that
can invite or repel and portray a straightforward
scene or a mysterious one.

When starting a tonal study I try to identify
the extremes of tone. Placing the very brightest
and darkest objects on the paper during the first
stage helps me to establish the value of all the
other tones against those two extremes.

It is sometimes difficult to judge one tone in
relation to another unless you have one control

▲ **SANTA MARIA DELLA SALUTE, INTERIOR**
48 × 66 cm (19 × 26 in)
*This painting is as much about the drama of tone
as it is about architecture. I also attempted to play
off the harder marks on the right-hand side against
the softer edges in the marble floor on the left.*

area, either black or white, with which to assess
the range. If you have subtle variations of tone in
front of you, put a sheet of white paper from your
sketchbook beside your subject, making sure that
it is picking up exactly the same available light
that is falling on the subject. This will give you a
key against which you will be able to judge all
those other values.

Expressive use of colour

The psychology of colour is well documented and everybody reacts in quite a predictable way to certain colour values. Since painting is not only about describing a subject but also about expressing various emotions such as anger, reverence or joy, this aspect of colour is another tool you can use in your painting in order to communicate your feelings to the viewer.

Before you begin to paint, establish in your mind what the general colour range of the painting that you are working on is to be and keep your palette based on this premise. If you want the mood of your painting to suggest melancholy, for example, choose a subdued range of colours; if you wish the emotional impact to be exuberant in spirit, brighter, more primary colours would be the natural palette to choose from.

With a box full of pan colours there is a real temptation to dig in and use everything, with the result that the colour range becomes far too complicated and the mood is dissipated. Using tubes will help you to limit your choice, as you have to make the decision to take the caps off.

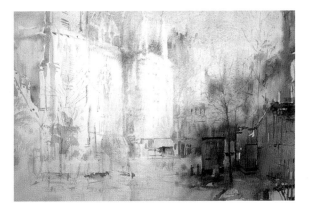

▲ **TAXICAB RANK**

30.5 × 40.5 cm (12 × 16 in)

This was painted from a childhood memory. The warm area at the bottom has the intimate quality of a fuggy, smoky refuge for taxi drivers, set against the cool, austere, ecclesiastical buildings beyond it.

▼ **BOATS AT FAVERSHAM**

30.5 × 43 cm (12 × 17 in)

Bright, buoyant colour cleanly put down and then left alone will always give a sparkle to a painting. The optimism of the colour range here gives the viewer the impression of a sunny day at a harbour.

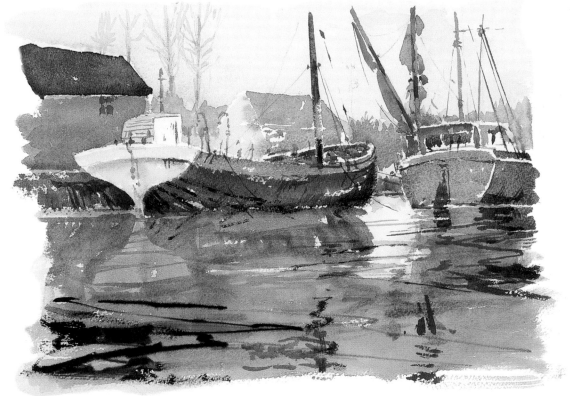

Hot and cold colours

The well-known sayings 'green with envy', 'red with anger' and 'a face as black as thunder' tell us that we have a strong response to colours. Notably, we read some as hot and others as cold, our interpretation being no doubt drawn from natural sources. Fire is orange and red, baked earth in a hot climate is red, deserts are a sandy brown, the sun is yellow; we regard reds, browns, oranges and yellow as hot colours. In icy landscapes there are hardly any colours in this part of the spectrum at all. At the North and South Poles, for example, there are blue shadows in the ice, dense greens in the sea, and grey skies full of snow.

In your paintbox there is probably a range of warmer and cooler colours within the blues, the reds and so on. It is a good exercise to make decisions about which pigments are hot and which cold. It is surprising how often people forget colour values once they open their box and resort to describing their subject in a merely factual way rather than using colour expressively.

▼ STEAM ENGINE
25.5 × 25.5 cm (10 × 10 in)
This quick brush study captures the heat of the day and the engine mainly through the overall use of a hot Burnt Sienna. The slight glimpse of cool blue sky enhances the warmth by comparison.

Enhancing the temperature

In painting we tend to use opposites to make a statement. To make something look large we place something tiny beside it; if the painting is full of light we need to have plenty of darks present; and to make a painting hot or cold, and therefore intimate or reserved, it is a good idea to include a little of the opposing colour to enhance the viewer's reading of the main colour temperature.

Hot and cold colours can be used to reinforce the message that is given by other elements of a painting. A landscape format with serene horizontals can be enhanced with cool, relaxed colours – blues, greys and greens – especially if they are within a narrow tonal range. Here format, composition, linear design, tone and colour are

▲ OAST HOUSES IN WINTER

28 × 35.5 cm (11 × 14 in)

Everything about this study speaks of cold: the angularity of the winter trees, the whiteness of the paper and above all the simple use of slatey blue. The oasts are little touches of hot soft-edged colour glowing behind and that little bit of heat makes all the rest go down a degree or two in coldness.

all used to induce the same feeling of calm. By comparison, a vertical composition full of strong tones and striking diagonals would benefit from hot reds, oranges and browns to have its fullest impact. These are not rules to be followed doggedly; you can combine either some or all these elements in your paintings as both the subject and your response to it seem to demand.

Spatial relationships

As well as their psychological effects, hot and cold colours also have the visual characteristic of advancing and receding respectively. Far-off hills in the landscape appear blue, a phenomenon known as aerial perspective that is invaluable to the artist trying to create a sense of distance, but even in an abstract context colours will always separate spatially; if you paint them all side by side on a piece of paper some will advance and others recede. Try placing a red and a blue square of equal mid-tone side by side and see how the red jumps forward. This was much employed by Canaletto, who placed a red hat or a red sash on a foreground figure in nearly every painting to bring some intimacy to his detailed city scenes.

The influence of tone

The tonal quality of a colour is very important in this context because a dark tone will always come forward from a light one. This allows huge permutations for you to use in showing space in your painting. Paint another blue mid-tone square then add a red, this time making it a darker tone. Compare it with your two mid-tone squares and you will see that the red has come forward even more. Next, paint a dark blue square and a light-toned red one to see that the cool colour now advances and the red recedes, destroying the familiar concept of how hot and cold colours should behave.

The alternation of hot and cool colours in differing tones to make them go back and forth in the composition will give your paintings a good deal of extra vitality. Make some little studies that concentrate purely on spatial relationships resulting from the use of colour and tone, then begin to include this idea in paintings in which colours are also used for their emotional qualities and in which tonal or linear concerns dominate. This sensitive use of colour will add greatly to your enjoyment of the painting process.

▼ **BLUE LORRY**
12.5 × 18 cm (5 × 7 in)
This simple study of a lorry and an interior was not done as a portrait but as a look at some of the spatial relationships in the subject to see if they would work well in a finished painting. I have subdued the objective aspect – although everything is in the right place it is not a detailed study of the object but of the relationships of the colours.

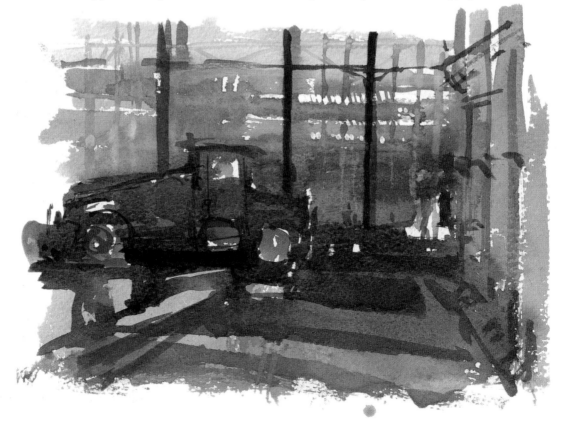

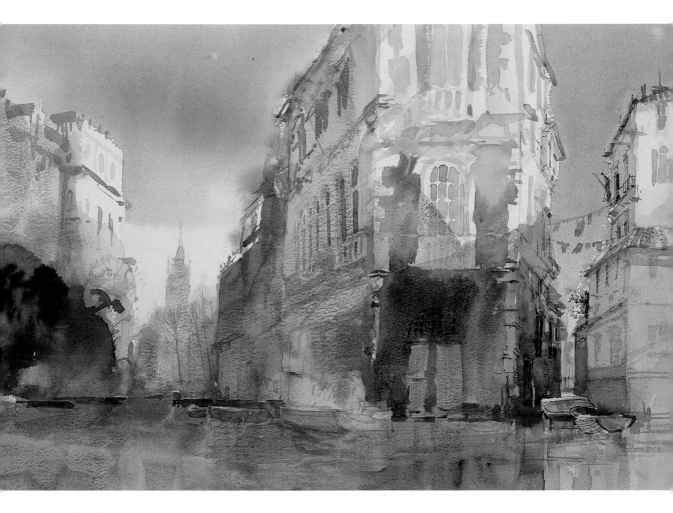

Using the idea

The receding tones and colours caused by aerial perspective are probably the easiest way available to us of showing three-dimensional space on a flat sheet of paper. Placing light washes in the far distance, mid-tone washes in the middle distance and dark tones in the foreground is a safe and dependable method of working, but it is possible to introduce more variety to your painting technique by exploiting colour temperatures within neutral tones.

Mixing two complementary colours, one warm and one cold, will provide a neutral, but by adding more of one or the other you can affect the spatial values very subtly. If, for example, your painting contains a large amount of blue and red, mixing those colours to make nearly all the neutral mid-tones will allow you to vary how much they advance and recede.

▲ WASH DAY

38 × 56 cm (15 × 22 in)

There are many principles at work here: the recession of colour from warm to cool is one, while the change of tone in the sky from dark blue at the top to quite light at the bottom pushes the buildings forward. They are dark at the base and become lighter at the top, giving a vertiginous effect.

Rather than always working from light to dark, try a landscape study by starting with subtle mid-tone grey colours mixed from warm and cool pigments. This will give the painting an overall continuity within which you can place high spots of colour.

Neutral tones made of hot and cold colours must be put down very quickly and cleanly. Overmixing will make them go very dead and flat, causing them to jump forward in the composition.

FOCUS ON...
using black and white

Black and white are not normally recognized as colours, but they do have their own useful characteristics. They are very flat visually and tend to jump forward when seen alongside transparent watercolour, but there are times when you may want that effect. In a picture of chalk cliffs, for example, the chalky, reflective quality of white paint can describe the surface of the cliffs, set against a much softer treatment of the other elements of the landscape. In industrial scenes where paint has been applied to surfaces, mixing black and white with other pigments in your palette will give you the flat, reflective colour that you need.

▶ **COASTAL CRAFT**
33 × 45.5 cm (13 × 18 in)
This is basically a black and white picture with some colour notes in it. I sprayed on some matt black car paint to give a mist of dark tone at the top and to a lesser extent in the foreground.

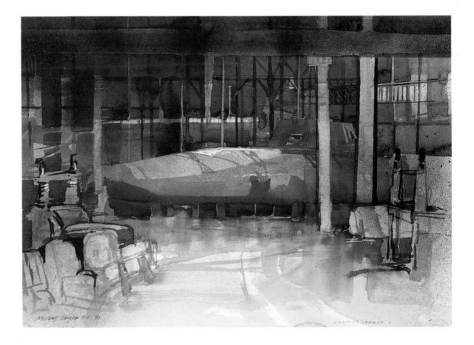

Using black

Black progressively diluted with water	⎤ Tonally the same but the first one is transparent and the second is opaque
Black mixed with white	⎦
Black mixed with Cadmium Red	Provides subtle browns
Black mixed with Lemon Yellow	Makes subtle greens
Black mixed with French Ultramarine	Produces slate blues

Adding white to primaries

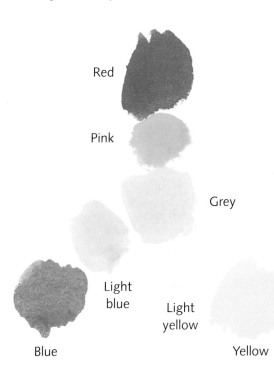

Red

Pink

Grey

Light blue

Light yellow

Blue

Yellow

Mixing blacks and whites

Black can be blended with pure colour to give subtle shades with the ability to go to extremes of tone. Add black to the colour; if you try to add colour to black you will have to mix very large quantities before you reach the colour you want.

Adding white to colours produces startlingly flat pastel shades that advance in a painting. You can create exactly the same colours by diluting the pigment and letting the white of the paper work for you, this time achieving a transparent colour with depth. By using these two methods together, you can show recession very subtly.

There are variations in black and white pigment, so consult your colour chart to discover their staining power and degree of opacity. Try some studies on mid-toned paper, using black and white to make positive shapes and learning more about their characteristics.

▲ **White as a mixer**
Adding white to the three primary colours produces flat pastel shades. If you mix these three pastels together the result is a subtle grey that can be varied from warm to cool depending on the ratio of the colours you mix.

▶ **THE CHARLES BRIDGE, PRAGUE**
20.5 × 20.5 cm (8 × 8 in)
In this study I worked on a mid-tone paper to explore both the blacks and the whites in a positive way. Whites too often appear by default when the artist is concentrating on dark marks to explain the objects in the scene.

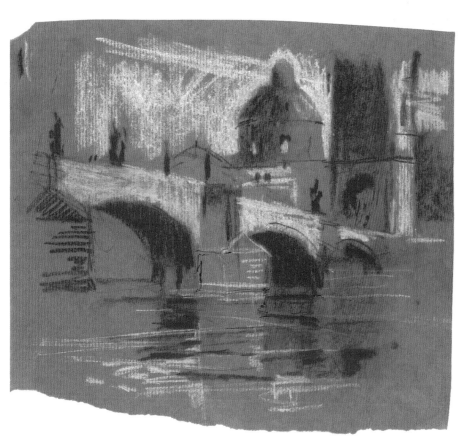

DEMONSTRATION

A quiet interior scene

Sometimes an object that I pass every day catches my eye and I see it as I have never seen it before. In this case it was the first bright sunshine of the year picking out the flowers of the Christmas cactus on our piano, a gentle domestic subject brought to life by the startling diagonals of the shadows on the floor and piano. Oblique shadows move very fast across vertical surfaces, so I had to record them quickly in my sketchbook.

Palette

Cadmium Red

French Ultramarine

Burnt Umber

Burnt Sienna

Lemon Yellow

Brushes No. 2 mop · 50 mm (2 in) hake
No. 10 sable round

Permanent Mauve

Hooker's Green Dark

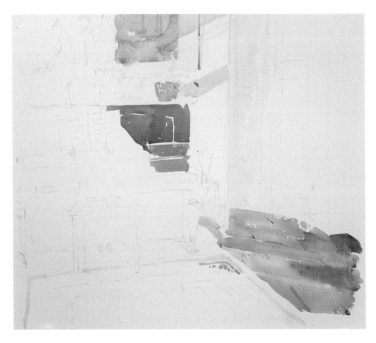

1 The very first stages of the painting process were to lay the pure areas of colour – the flowers, the sunlit corner of the piano and the light on the floor. I applied them cleanly and quickly to preserve their luminosity, but at this stage, without the dark tones of the shadows that were due to appear next to them, I could not be sure that I had the tones right. I put in some strong colour on the Christmas cactus flower.

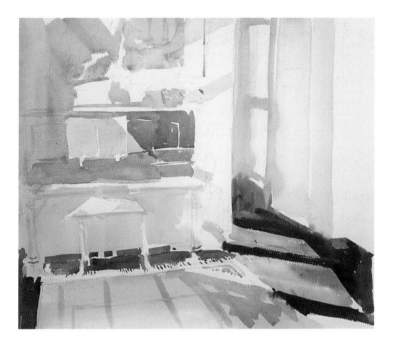

2 I laid the cool areas in the background to establish the relationship between the hot and cool areas of the painting. This also isolated the few areas of white paper – the music and the edge of the doorframe and the wall – which are strong elements in the composition. With the hake and the No.10 round, I laid cool and warm washes on the carpet and wooden floor respectively.

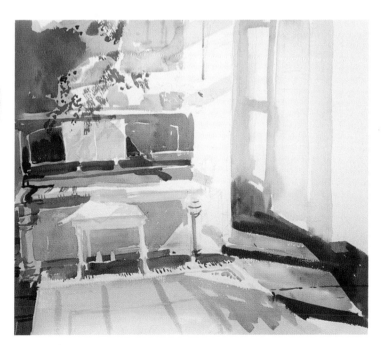

3 Next I put some depth into the areas behind the piano, making them darker and more recessive. I dropped in a darker tone wet-into-wet to hint at the shadows from the foliage, using a blue-green mixed from Hooker's Green Dark and French Ultramarine.

4 After darkening the plants further I also darkened the shadow beneath the piano keyboard. I softened the washes on the carpet, brushing a slightly neutral tone of cool blue all over it with the hake. Right from the start there had been a curved shadow blocked in with a bluey wash for the umbrella stand and now I put in the basic shape of the stand itself, using flat colour.

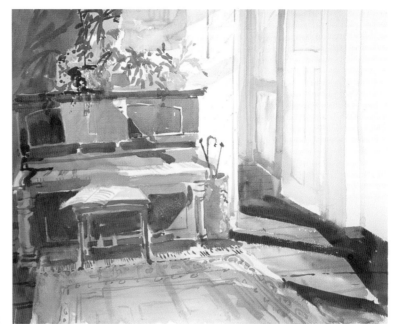

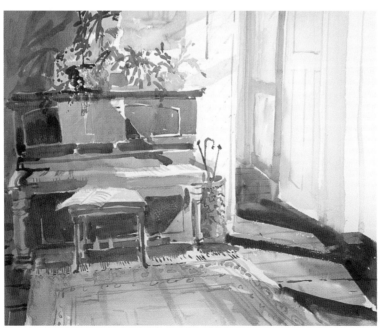

5 Next I added detail on top of the washes in the umbrella stand, using a No. 2 mop. I worked on the view through into the far room to show the light outside the windows, using very cool bluey greens just to give an indication of the garden. Moving to the area above the piano, I added more green details to the plants.

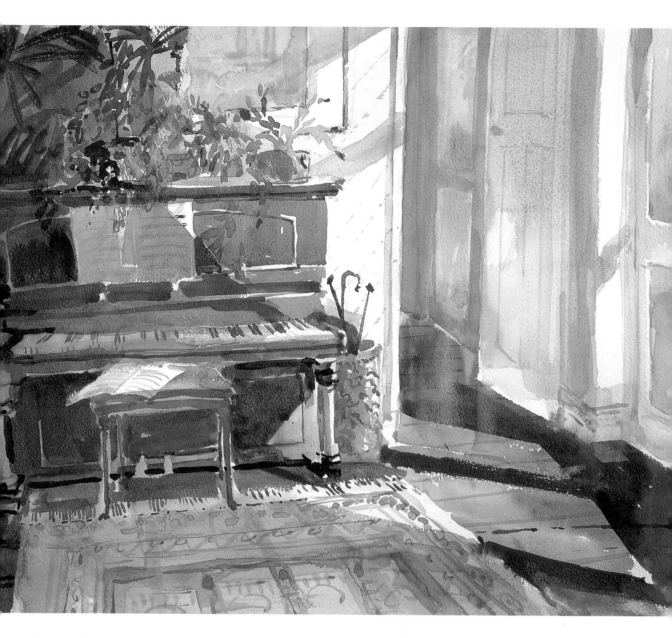

6 To give the impression of an oriental carpet I put in almost calligraphic soft-edged marks of French Ultramarine and a warm purple made from Cadmium Red and Permanent Mauve, using a No.10 round. I added some muted French Ultramarine to the cushion to calm down some jumpy whites and eliminated other highlights in the dark areas as they were lessening the effect of the light flooding through the window. The walls on the right were also darkened with cool blue-grey washes to make the area just inside the door look very white by contrast. The piano keys were put in with little slashes of dark brown, using a No.10 round.

▲ THE PIANO

40.5 × 51 cm (16 × 20 in)

A split-second reaction to sunlight streaming through a window is quite difficult to keep fresh throughout the painting process. Simplicity is the key, so as far as possible the washes were just put cleanly down and then left alone.

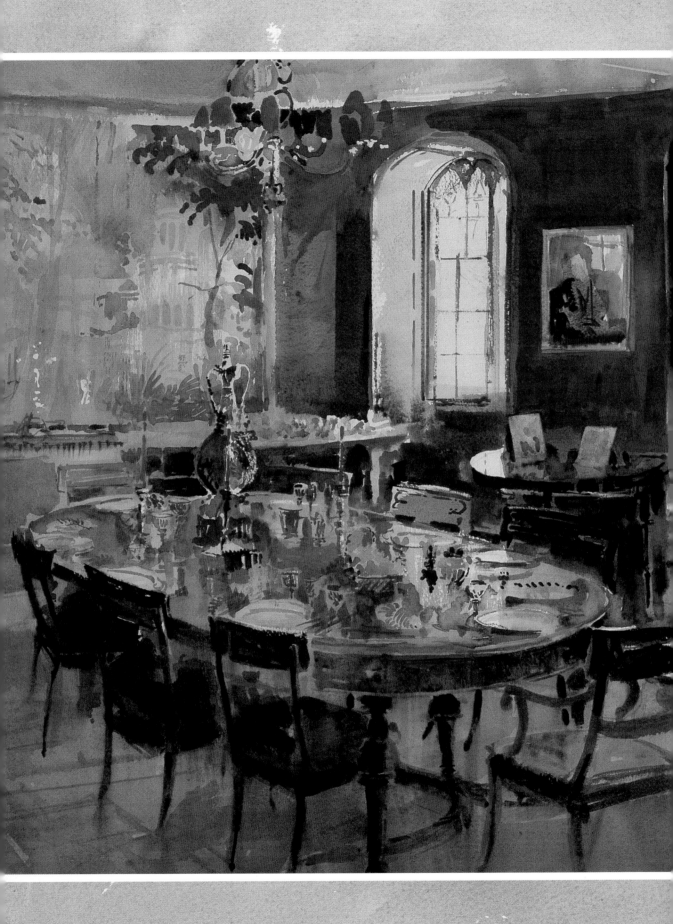

Composition

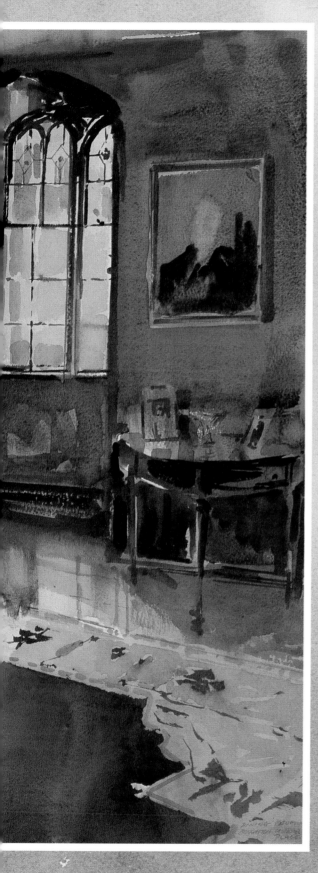

Once you have decided upon your subject you are faced with more choices: what to include, what to omit, how wide a view to take, what format to work within and what to concentrate the eye on as the focus of the piece. This exercise is composition, or in other words, the placing of all the different elements in relationship to each other.

◀ BOUGHTON MONCHELSEA DINING ROOM
51 × 61 cm (20 × 24 in)
This quite complex painting allows the eye to travel round it in many different ways, lingering on apparent detail and moving faster over looser areas, balancing lights and darks and revelling in rich, simple colour.

Choosing a format

An oil painter has to make very specific decisions at the beginning when preparing a stretched canvas or cutting a board, but as watercolourists we too often just use the format provided by the paper manufacturers. Even the decision to work portrait (upright) or landscape (horizontal) has implications for the final result, but more adventurous choices than that are possible. You do not always have to work within the manufacturer's rectangle; squares, circles and triangles are all easily cut from paper.

Remember that your paper has two sides and can be hung up so that both are on view. We tend to think of paintings as two-dimensional items viewed hanging on a wall, but there is no reason why you should not make your paintings into banners or even turn them into three-dimensional shapes and triptyches by folding, cutting and gluing.

This experimental approach is helpful if you are inhibited about the business of painting. The assumption with watercolours is that they are produced for a long, prestigious life behind glass, and making a more domestic object with perhaps only a short life will liberate your creativity in a way that will benefit your traditional paintings.

▲ **THE GARDEN AT THE VICTORIA & ALBERT MUSEUM**
20.5 × 15 cm (8 × 6 in)
The two trees are symmetrical within the portrait format and each has a group of figures at the base. Placing the main figure on the chair off centre tips the balance slightly to one side so that the composition is not too boringly symmetrical.

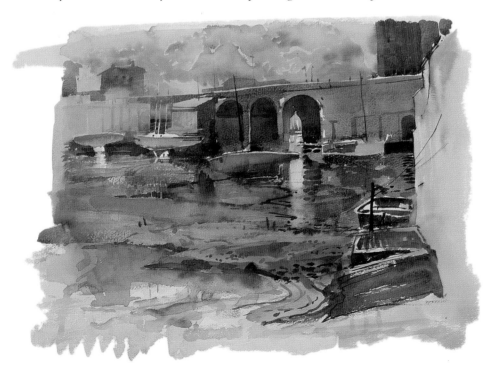

◀ **BOATS AND BRIDGE**
25.5 × 33 cm (10 × 13 in)
This typical landscape format suits the calmness of the scene. Most of the obvious subject matter is clustered towards the edges, giving a feeling of spaciousness.

Squaring the circle

The square format can be quite a claustrophobic space to work in, but it has a quiet and intimate feeling because it is comfortably enclosed. You can almost imagine a circle inscribed within the square and the eye travels happily round and round, staying within the confines of the shape rather than wandering off directionally.

▼ STILL LIFE

38 × 38 cm (15 × 15 in)

All the objects here work comfortably within the confines of the square, with just a few little linear marks to give tension. I began by painting all the dark areas around the outside, working in towards the subject. They act almost as a frame to the painting, focusing the eye towards the centre.

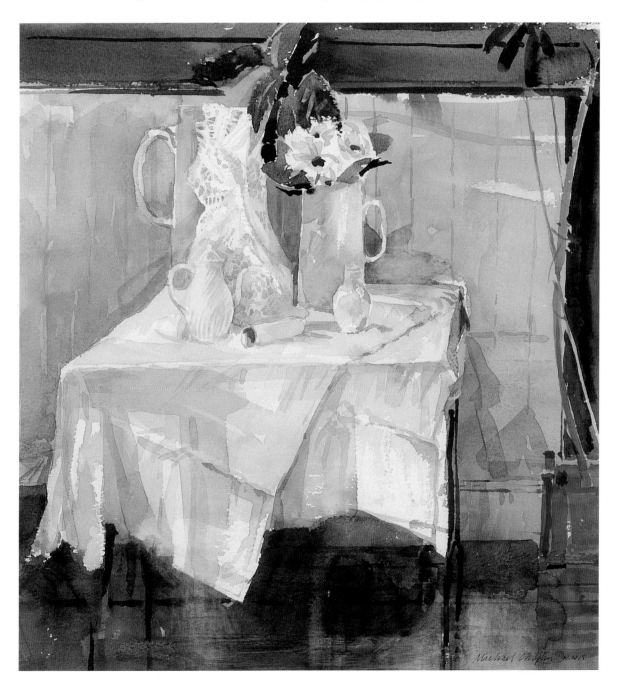

Linear composition

Lines have two functions: they are either an expressive linear element in their own right or a way of isolating shapes and areas.

The Swiss artist Paul Klee (1879–1940) used to give his students a drawing exercise he called 'taking a line for a walk' as a way of dividing a format into areas with a flat linear pattern. Try this for yourself. Start anywhere at random and keep going wherever you will – angular areas can develop into a relaxed, sensual, curved linear design and vice versa. The important thing is not to stop. This exercise will make you very aware of how you isolate shapes when you draw.

Line can be very important as a dynamic compositional part of a painting. The viewer's eye can be led on a journey around the painting, encountering incidents as it travels, and the whole feel of the painting can be established, be it serene, dramatic or joyful.

Try to be as confident with the final linear touches in a painting as you probably were in the initial sketch. Experiment with watercolour pencils or cut sticks and quills to use with inks – less intimidating tools than the finely pointed sable brush, which can make people paint too tightly. They can also provide the strength you will need in a large painting or one with powerful tones and colours.

Like the landscape format, the use of a basically horizontal alignment of lines will give a feeling of calmness and rest (left). *Verticals suggest something much more uplifting and optimistic* (below left). *Diagonals always add drama, especially when used with strong tones* (below right).

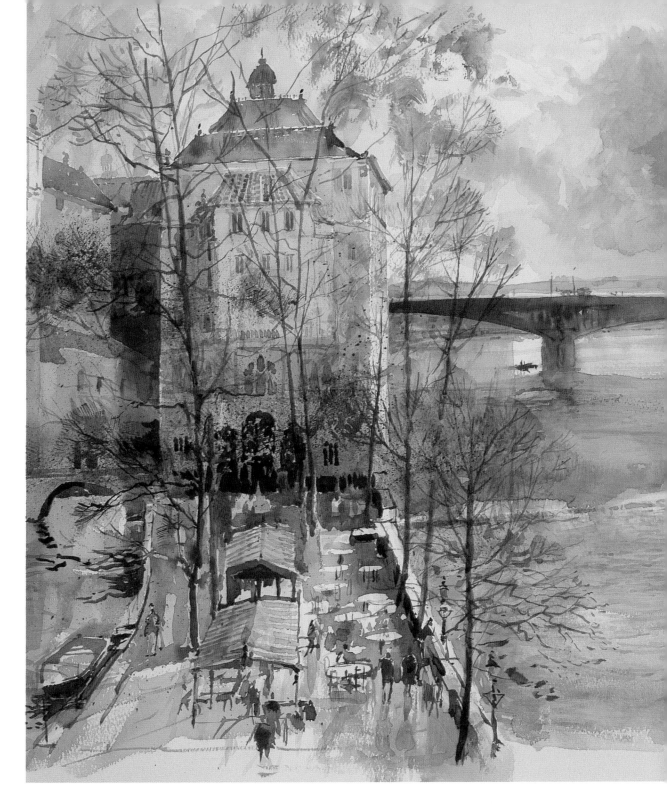

▲ **CHARLES BRIDGE, PRAGUE**

45.5 × 25.5 cm (18 × 10 in)

The vertical lines of this composition run from figures to trees to buildings so that the eye is on a constant journey, suggesting the excitement of the busy event going on below. The hard linework in the foreground makes small frames within the painting for the viewer to look through, encountering little incidents of light, narrative or architectural detail.

FOCUS ON...
the Golden Section

We may not consciously notice aesthetic values in our daily lives, but we are nevertheless attuned to a certain aesthetic balance. As artists, when we mount a painting we leave a wider edge at the bottom because the picture will appear to drop down in the frame if it is centrally placed; and as householders, when we buy a panelled door we invariably find that the upper panels are shorter than the lower ones.

What we often take to be an instinctive sense for design and composition is in fact rooted in mathematics. The concept is known as the Golden Section and is based on the ideas of Fibonacci, a 13th-century Italian mathematician, who published a numerical progression in which each number is the sum of the preceding two. The series thus begins 1, 1, 2, 3, 5, 8, 13, 21, 34, 55, 89, 144, 233 and throughout the series the relationship of each number to the succeeding one is 0.618, or about two-thirds.

▼ **GATEWAY TO THE ACROPOLIS**
45.5 × 61 cm (18 × 24 in)
The buildings of the Acropolis are mathematically and aesthetically balanced. The piece of paper I used here is very close to a Golden Section format, though I did not consciously plan that.

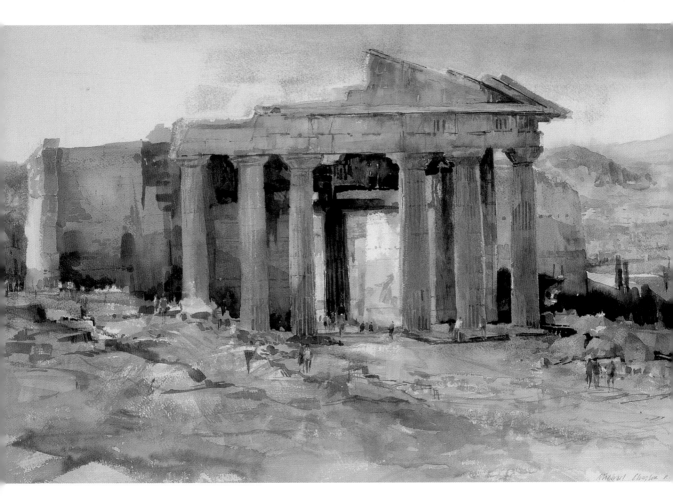

◄ **Making a Golden Section rectangle**
Start with a square and, using the midpoint of the baseline as a centre, draw an arc from the top corner. Construct the rectangle from the point where the arc crosses the baseline. It is a slightly longer shape than the paper manufacturers provide and is a very good landscape format.

The Golden Section in practice

While they long preceded Fibonacci, the Ancient Greeks understood the aesthetic rightness of the proportions and used them in their architecture. But although mathematical theories and ancient buildings imply considerable learning, if you ask someone to pick an aesthetically comfortable place in a simple line they will nearly always point about a third of the way along it. Look at the work of the Old Masters and you will see that the area of focal interest in a painting is very often located in the Golden Section.

This proportion also appears in nature. A sunflower seedhead, for example, is made of two series of spirals radiating from the centre, one to the left and one to the right, and the numbers of spirals in each series are often adjacent in the Fibonacci series. It is an engrossing subject, and studying it further will add to your appreciation of the natural world.

▶ **A shell drawn in a Golden Section rectangle**
The squares in this rough sketch follow the Fibonacci series, each being approximately 0.618 of the dimension of the next. The spiral is a series of arcs that would result if drawn by a compass with the needle set in one corner of each square. The centre of the spiral is on the central spot of the Golden Section.

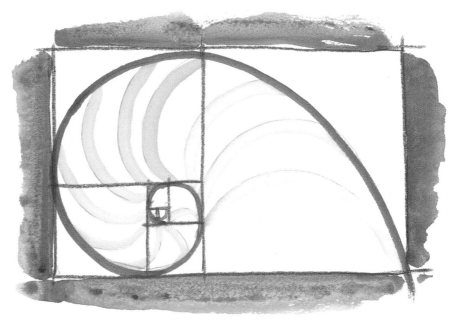

Tonal composition

The first step in embarking upon a tonal composition is to analyse the subject in front of you in terms of light and dark. Half-closing your eyes as you look at it will get rid of the colours and allow you to see the extremes of tone. You will be surprised how often the scene is one of isolated light areas within a generally dark area, even in a landscape.

Try painting pictures in which the design and placing of the light areas is the whole purpose of the exercise; it will really strengthen your images. A common mistake is to draw objects of interest dark at the outset, but this results in a thin and pallid painting because large areas of white paper are left to be covered with thin, light washes. Rather than thinking of the marks you are making as the positive areas in the painting, paint the dark areas around them and you will achieve much more tonal strength.

Because watercolour dries lighter the tendency is to underpaint tonally. My students often ask me how to get more light into their painting, and the answer is simple but not immediately obvious: use more dark tones, because every mark we put on paper needs something to react to. Being bold with tone gives better results every time than being indecisive.

▼ **LIGHT ON WATER**
12.5 × 18 cm (5 × 7 in)
This small sketch, done on tinted paper in less than five minutes, shows the vibrant effect of fast brushwork in strong, bold tones to give the feeling of light dancing on the water.

Using a subtle tonal range

Subtlety is a word often used in the context of watercolour painting; because of its transparency the most delicate of tones can be laid as washes and this makes it an excellent medium for monochrome studies. Try a painting which has just three washes of one colour, one light, one medium and one dark. The white of the paper can supply a fourth tint.

To explore the use of monochrome further, set up a simple still life of domestic objects such as cups, vases or boxes which are all white and light them harshly from one side – a table lamp with the shade removed will suffice. This will give you the opportunity to produce a subtle composition

▲ CYCLISTS IN BRUGES (detail)
I was amused to see these youngsters in Bruges cycling round a bollard in the shadow of a statue of some bicyclists. Using an Indigo monochrome wash on blue-toned paper allowed me to make the most of the subtle interplay of tones.

of gradated tones and is a very good way to train the eye to consider the relative values of tone against tone. If you feel daunted by this exercise, try it as a light tonal pencil study first and then put your washes over the drawing. For both of these studies you will need to choose a colour with a wide tonal range rather than, for example, a light yellow that will not give you dark tones.

Colour composition

Our modern paintboxes have palettes that would make artists of the 18th century green with envy. In terms of the variety of colours now available to us we have benefited hugely from the by-products of the oil industry, but the choice can be intimidating – or irresistible. The colour range of a painting can easily get out of hand, with too many pigments appearing haphazardly.

Even when the main thrust of the painting is that of colour, tone is still a strong consideration in terms of the overall composition. If you have a very wide tonal range it may help to keep to a quite restricted colour palette – for example, choosing to make a basically blue or green painting – so that you can make the most of the gradations of tone.

▲ GETTING UP STEAM
51 × 61 cm (20 × 24 in)
The shiny colours of this saddle tank engine are echoed in the building around it. The zigzagging tonal composition is quite strong and unusual and if the colour composition had followed a different thrust the eye would have been confused, so strong colours have been kept within the strong tones.

In such a composition, give yourself the luxury of small highlights of colour. Two highlights will always have some recognizable relationship but working with three becomes much more complex and difficult to control, particularly if they are all primary colours, when the viewer will be confused as to where to look. If two highlights are primaries and you want to introduce a third highlight, mix a strong tone from those primaries instead.

Colour mixing

One way to control your palette is to use subtle mid-tone hues as a backdrop to the main incidence of colour. In many of the paintings in this book you will see subtle areas of colour made by mixing two of the strongest colours in the composition; red and green, blue and orange, and yellow and purple are the obvious ones.

Whether you want to make your colour fresh or subtle, do try to keep it pure. It is very easy to produce mud if you put too many elements in your mix. A primary and a secondary colour will together produce a third (tertiary) colour; if you put one more colour into the mix it will probably go very muddy and lose the luminosity that is the characteristic of the medium.

One way to avoid overmixing is to get your strength of colour with your first hit as you go into the paintbox. If you do not use pan paints every day they will become dry and you will produce a pale imitation of your intentions. To keep them moist, dampen a piece of kitchen towel under the tap, put it in the box and close the lid. Wrap it in a polythene bag and leave overnight, during which time the gum arabic in the paint will suck all the moisture out of the kitchen towel back into the paint.

▼ **THE TRAGHETTO**
51 × 61 cm (20 × 24 in)
This formal, almost theatrical painting is mainly about colours working side by side rather than being used to show spatial depth. The eye travels from one area of colour to the next and enjoys the painting in terms of its colour rather than looking for a three-dimensional effect.

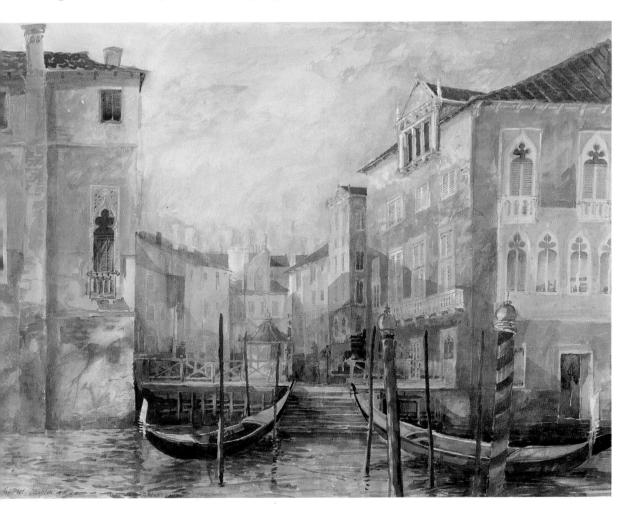

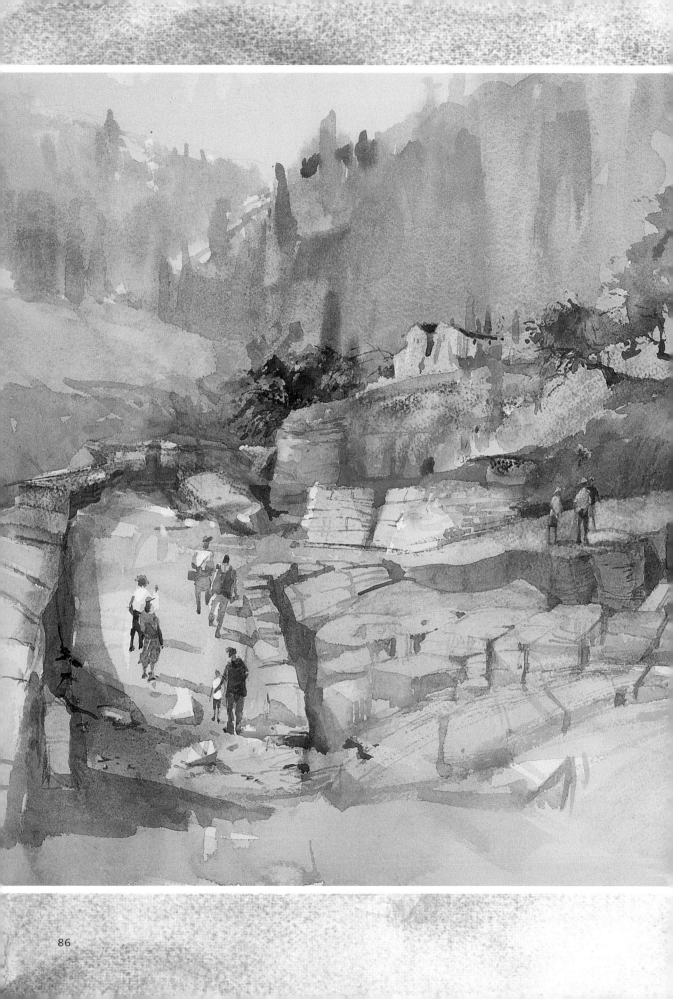

The Natural Landscape

Traditionally, British watercolour painters have always had a strong affinity with the landscape and they have also been great travellers at home and abroad. Working *en plein air* makes us aware of the subtlety of nature and what we can learn from it about line, tone, colour, pattern and in particular a sense of the place.

◄ FOOTPATH AT DELPHI

51 × 71 cm (20 × 28 in)

This study of a hillside path at Delphi in Greece captures some of the quiet poetry of this magical site. The yellow colour range was not in fact present in the landscape but conveys a sense of heat that describes the emotion of the scene.

Skies

The range of tones in a clear sky from the horizon to immediately overhead is remarkable. This is because when we look upwards our view through the earth's atmosphere is shorter than when we are looking straight ahead towards the distant sky, so the blue wavelength is less distorted by impurities. Gradating to lighter tones of blue towards the horizon is essential to establish a sense of distance, and if you fail to observe this any work you put into achieving a recessive effect in the land below will be wasted.

The angle of the sun has a huge effect on skies, particularly if there is reflected light from large expanses of water which is bounced back up to the clouds. Try working at different times of day in varying weather conditions and alter your own position in relation to the light.

▼ **SEA AND SKY WITH CLIFFS**
25.5 × 30.5 cm (10 × 12 in)
With the sun high and coming directly from behind me, the colours in this painting are pure and fresh. The cirrus clouds, lifted out of the wash with a tissue, are flat white.

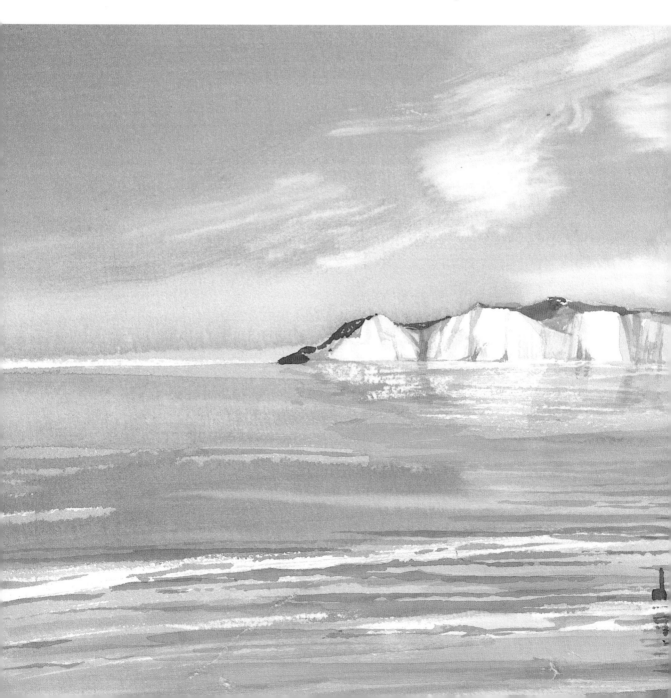

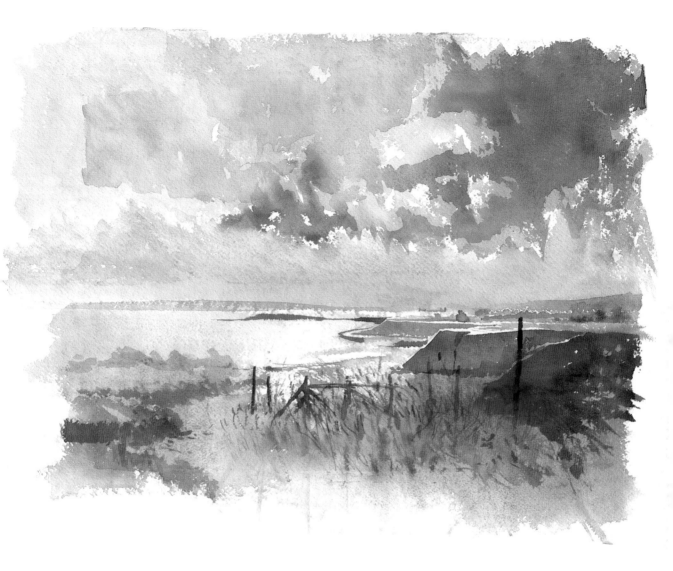

Breaking the rules

We are always told not to put the horizon halfway up the composition because it will divide it in two. Here I have shown two studies that break this rule and make a strong point. The sky has such an effect on the landscape, particularly in the case of reflections, that the two elements often both fall within the same paint range. In these two paintings the composition becomes complete because of the echoes of colour and tone between the land and the sky. The horizon is bridged and the painting is balanced.

Wherever you choose to place your horizon, do not think of the sky and the land as two separate entities. If you paint the sky as one operation and the land as another it will be

▲ **SEASHORE AND SKY**

20.5 × 25.5 cm (8 × 10 in)

Here I was looking into the evening light. The sun is low and silhouettes the clouds, giving strong tones and subtle colours. The tones also describe the volume of the clouds.

obvious that the painting is split in two. You need to take a unified approach and this does not apply just to colours and tones but also to the type of marks, be they calm or vigorous, so that the temperament of the painting is coherent.

Remember that the sky is always changing and is a constant source of fresh subject matter, even if you have to paint through the window because of bad weather.

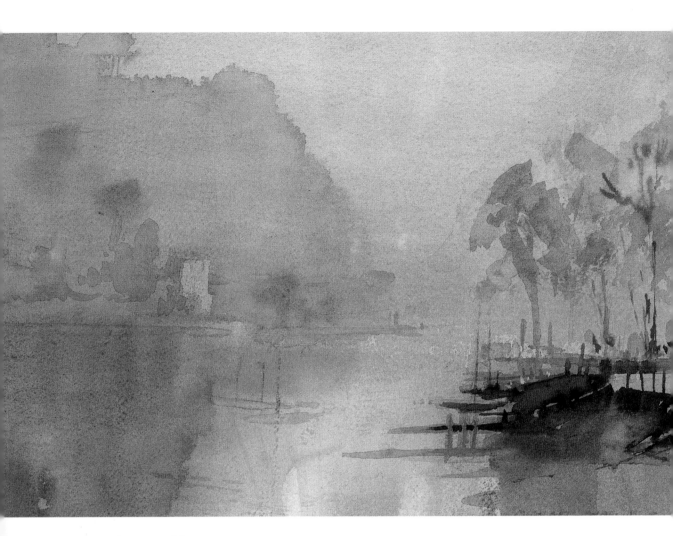

Weather effects

Watercolour is a particularly good medium for capturing fleeting moments of weather. Its very elusiveness as a way of working will sometimes catch exactly that transparency of space that weather brings.

You often cannot see weather, only the results of it. I do not recommend that you strap yourself to the mast to capture a storm at sea as Turner did, but, more realistically, that you write notes to use as an *aide-mémoire* when you are back in the studio. It is quite difficult to resolve a vague intellectual idea about a particular weather effect into the practicalities of painting, but if you write it into a sentence you actually have to formalize that idea into something quite specific. 'The wind whipped the leaves from the trees' or 'the sky

▲ **ITALIAN LAKES, EARLY MORNING**
25.5 × 30.5 cm (10 × 12 in)
During a journey home from Venice on a very early morning I made an unscheduled stop to capture these swathes of mist rising from a lake, shortly to be burnt off by the rising sun – a magic moment.

turned dark with snow, speckled dark and white in a whirling texture' gives you the factual information you need in the studio when the painting is underway. You can also conjure up the emotion involved: 'wind whipped' is alliterative, sharp and spiky and inspires brushwork with hard spiky edges and some sharp diagonals. I find there are such analogies between the structure of writing and painting that working in another medium for a few minutes can give me the clue as to how to express the idea in paint.

Subtle treatments

Mist, rain and snow act as a transparent or semi-transparent veil of weather interposed between artist and subject. Mist is one of the most difficult weather effects to catch but it can be done by laying veils of horizontal transparent wash over the underlying painting to obscure the subject beyond slightly. These need to be laid very fast or they will disturb the painting underneath. This is a time when acrylic paints are useful. Used very wet they look exactly like watercolour but once they are dry they will not be disturbed by further washes, so you can lay a series of glazes of very pure, subtle colour.

On a gloomy day, do not be put off by the threat of rain – it can introduce highlights where previously none existed. Light reflecting from shiny surfaces can give a sparkle to paintings, and stones or slates that look monotone and flat when dry will become a pattern of light, medium and dark tones once they are wet. There is no need to show rain falling; dark clouds and reflections will tell the viewer the story, and you can also include figures with umbrellas or oilskins.

Snowy ground becomes a giant reflector and shines light upwards on to nearby objects and buildings. Normally the sky is lighter than the ground but now it will be a darker tone, especially if more snow is on the way.

▼ **CLOCK TOWER AT MOTE PARK**
25.5 × 35.5 cm (10 × 14 in)
The crispness of a cold winter's day is best reflected in colour put down fast and cleanly. The watery light of the winter months often reveals pure, clear colour as in the copper dome of the clock tower.

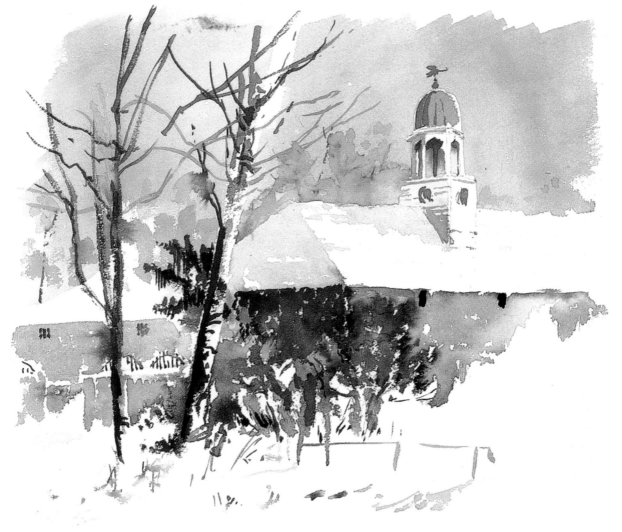

Water

When it comes to degrees of difficulty in painting, for most people the elusiveness of water ranks pretty high. In fact, there is no elaborate trick to painting water; you just have to study what is happening to the water in a small area. The larger picture is just lots of those little areas put together and it is merely a question of endurance getting it all down!

Many people find disturbed water harder to paint than a flat surface, but understanding the nature of the reflections provides the clue as to how to tackle it. Each wave is like two mirrors, one coming towards you and reflecting what is behind you and the other surface lying away from you to reflect what is in front of you. So, for example, if you have a big tree ahead of you and the sky behind, half the reflections will be picking up the darkness of the tree and the other half will be mirroring the lightness of the sky. The choppier the water, the more acute the angles and the more varied the sources of the reflections will be; the texture and tone will also travel further across the surface of the water.

Painting disturbed water is an instance when the camera can be a real aid to capturing the moment and showing you the reality of an apparently complex view.

▼ THREE UMBRELLAS, MONNINGTON COURT
30.5 × 38 cm (12 × 15 in)
The activity of the ducks is enough to create expanding ripples on the surface which broaden as they travel outwards. They affect reflections as they go, making for great interest in the foreground.

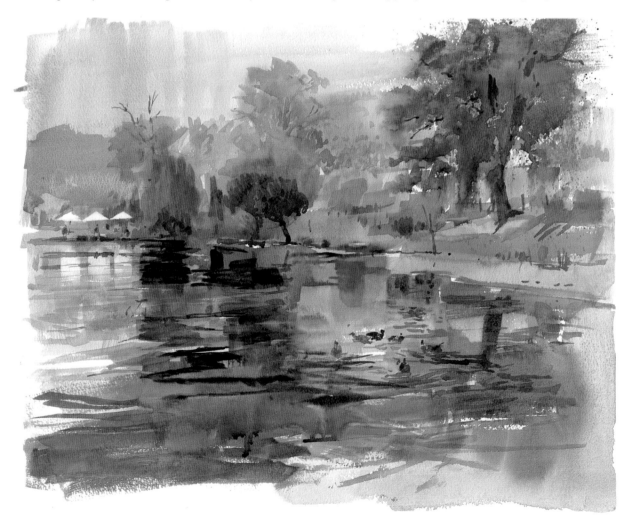

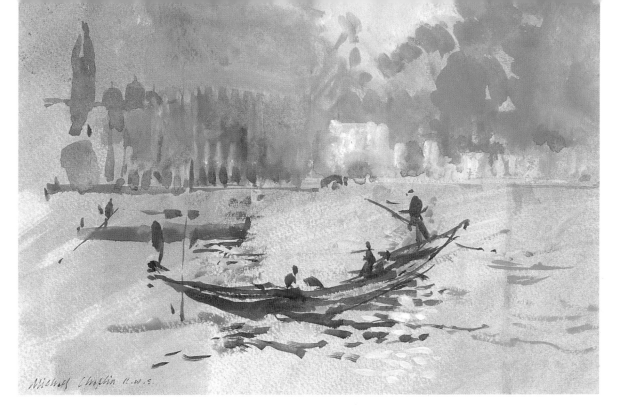

Movement in water

Showing movement in water allows us to explore the full range of techniques as we try to express the mood of a dramatic waterfall, a rushing rocky stream or the smooth slide of water over a boulder. Often the surfaces we want to show almost dictate the technique we need: the slow movement of a broad river inevitably suggests loose, almost casual brushwork wet-into-wet, whereas the staccato movement of water splattering onto a rock hints at scratching the surface of rough paper with a blade.

As so often, the technical answer lies in understanding your subject both intellectually and emotionally. I tell my students that with a vigorous subject I like to hear them working at the paper. If we are painting a storm and the studio is quiet I suspect they are not as emotionally involved as they ought to be! Try using soft, fluid techniques for soft, fluid movement of water and more aggressive, stabbing methods for water crashing on to rocks and your reaction to the subject will be communicated to the viewer.

▶ **WATERFALL** (detail)
This vertical format enhances the sense of falling water. Loose wet-into-wet brushwork is played off against the hard-edged reserved paper at the top of the waterfall.

▲ **VENICE**
30.5 × 38 cm (12 × 15 in)
Here the light choppiness of mid-lagoon Venice has been summed up with small gestural marks from the brush. They were stabbed on the paper in an almost pointillist technique to echo the way that the little wavelets were stabbing at the surface.

Trees

Trees are a gift to the artist; they offer colour, line, texture and tone in turn as the seasons change and because of their diversity of shape they give us a variety of compositional devices.

Different trees have different characteristics – some are linear, some textural, some tonal – and you do not have to place them in your painting in the position they occupy in reality. If a tall cedar of Lebanon would be compositionally more pleasing swapped to the other side of a spreading beech it is your prerogative as an artist to arrange them to the advantage of your painting. The shadows of trunks and branches thrown across the ground are very good linking devices, joining what could be isolated parts of the composition, so if need be, introduce a tree from your sketchbook to do the job.

To develop a real understanding of trees, study their detail. In the bark of silver birch you will find lovely little landscapes of horizontal rhythms, and an acorn cup is a miracle of symmetrical perfection.

As children we draw trees as flat lollipops and in adulthood we tend to regard them still as flat, linear shapes, but even in winter they do have volume. To show that, tighten up the edges of trunks that are nearest the viewer with warm-coloured hard marks from a fine brush and on the other side of the tree lay down more fluid, bluer, soft-edged marks. Give branches coming towards you stronger tone, sharper marks, tighter drawing and foreshortened outlines and you will begin to paint trees that look convincing.

▼ **PALM TREES, ATHENS**
25.5 × 30.5 cm (10 × 12 in)
To show volume some of these palms were painted wet-into-wet while others were put in with a much drier brush technique using darker tones. The figures give scale to the gently wind-rocked trees.

▲ **THE BANDSTAND AT KARLOVY-VARI**

30.5 × 35.5 cm (12 × 14 in)

All the tints and colours of autumn appear in this rich colour study, though the linear form of trees in winter is appearing.

▶ **TREES IN THE DEER PARK**

35.5 × 48.5 cm (14 × 19 in)

Here full-leaved summer trees give shade to deer. This straightforward composition carries its story at the bottom left.

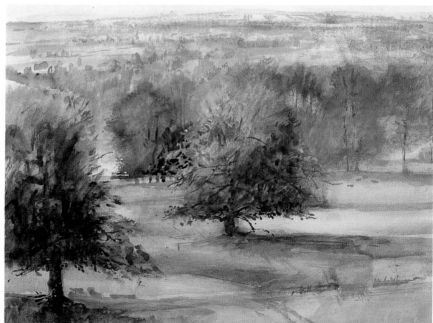

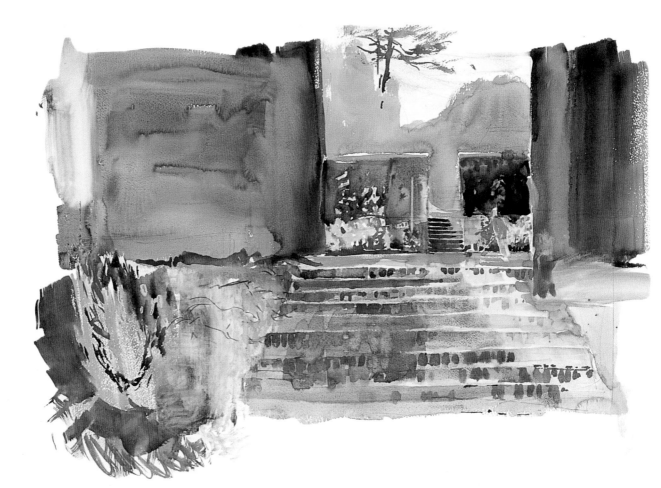

Garden scenes

There are two very different but equally valid ways of tackling a garden scene: either as botanical portraiture, getting in close to individual blooms, or taking a more painterly approach by borrowing colours from the garden and reinventing a picture with them.

If botanical correctness is your aim you will want your painting to have a high degree of detail throughout, but otherwise you should vary the finish across the painting. Gardens tend to be a blanket of similar weights of tone and colour so, to avoid a boring painting, change the pitch by leaving some areas unexplained.

▶ **LEEDS CASTLE**
45.5 × 56 cm (18 × 22 in)
Looking for the bones of a composition left me with this dynamic, almost abstract painting which has a vigorous descending zigzag compositional thrust and aggressive tones – a strong start.

▲ **MOWING THE LAWN**
45.5 × 61 cm (18 × 24 in)
I began this painting on site but was interrupted by a sudden violent thunderstorm. Shortly before it broke the colour of the plants had that strange glow to them that often precedes a darkening sky. Leaves turn their backs to the sky before a storm – an eerie moment.

Making the most of colour

We rarely encounter such colour as we find in gardens. Full-strength colour is a powerful tool in a painting, and to use it to its fullest extent work with tube paints or, if using pans, make sure the pigments are really moist. Placing strong colours against dark backgrounds enhances their quality; it changes them from being marks darker than the paper, which makes them duller, to marks that are lighter and more buoyant than their surroundings. To see how the intensity of the hue changes, put a dab of pure mid-tone colour on white paper and lay it on white and then black paper. It is a revealing exercise in how colour does not really have a tone or even an intensity until placed against another tone and colour.

Remember that a flower that is brightly coloured with the light full on it in the morning will become a study of dark silhouetted tone with the light behind it later on, so make colour notes if you feel the painting process will be lengthy.

▼ **THE WINTER GARDEN**
40.5 × 51 cm (16 × 20 in)
The formal conservatory offered a geometric background on which to lay the exuberant foliage of these exotics. The shadows on the floor provide frames and links within the picture.

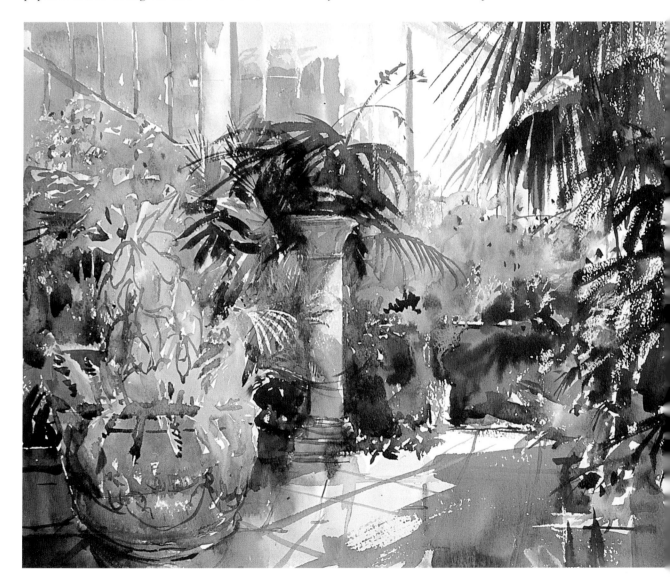

Classic landscapes

The inclusion of a landscape in a painting was once merely a matter of providing a backdrop for a portrait, narrative or architectural subject. Landscape was not regarded as a subject in its own right and it was often relegated to the hands of apprentices who would learn their trade in the studio of a master, later to be allowed to treat more important parts of the painting. Artists who travelled around accepting portrait commissions would even employ local people to paint the backgrounds for them.

The Flemish painter Pieter Paul Rubens (1577–1640) is generally regarded as the first artist with a real interest in landscape painting, and his influence helped it to break free of the confines of just being a backdrop and become a subject in its own right. By the 19th century it had become available to the public as a genteel pursuit – a label modern-day artists, and in particular watercolourists, are still trying to shake off. The tradition of the classic landscape, often the grand view of rugged and large-scale countryside, in fact demands considerable skill from artists as it requires them to communicate the feeling of the place – quite an elusive task to pull off successfully and one that requires commitment to the business of painting.

▼ **LEPE COUNTRY PARK**
35.5 × 45.5 cm (14 × 18 in)
As the British are a maritime nation the sea itself constitutes a classic landscape with a long tradition. This marine subject also has a narrative element in the anglers in the foreground.

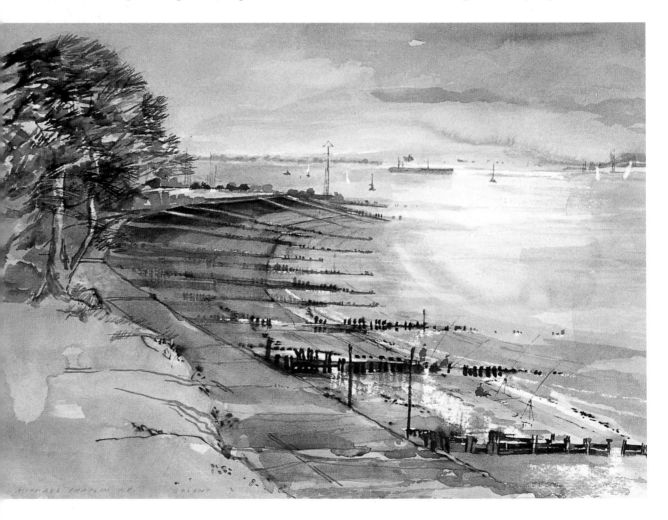

An illusion of space

When painting we spend much time translating the three-dimensional space in front of us into two-dimensional patterns on the paper. We try to trick the eye into thinking that the painting is a window through which we look out over distances, and a classical large-view landscape often contains a lot of empty space into that distance.

This presents the problem of how to treat these areas on paper, when in fact we are trying to paint an absence rather than a presence. Out and about in the country, we may stand on the brow of a hill and say how lovely the view is when really we are reacting to the sense of freedom and open space; there may be no subject matter until the eye reaches the far distance, having rushed across the foreground and middle distance, which in a painting can be quite boring.

▲ STEEL RIGG

35.5 × 51 cm (14 × 20 in)

All the obvious subject matter occurs in one half of this painting while the other is virtually empty. Playing off dense areas against empty areas increases the sense of space.

These large empty areas often capture the essence of watercolour – its ability to be sensual and poetic on its own terms even if it is not describing a particular feature. Many grand landscape paintings have a sense of the place that comes just from the quality of the paint, so let the watercolour itself do the work for you. An area of beautifully granulating pigment or gently textured foreground, for example, can be used to direct the eye to a specific focal point, which may be merely an area of strong colour or dark tone.

Narrative landscapes

Before the age of mass literacy in the West, paintings were the main way of imparting information – hence the rich heritage of religious paintings from which we draw most of our history of art. Quite often these early artists were anonymous technicians telling either a religious or a political story and it was only with the rise of humanism in 14th-century Europe, when a concern with human achievements in art and science displaced medieval religious authority, that the painter become a personality in his own right and was able to choose his own stories.

Most pictures tell a story, whether complex or simple, and one of the painter's jobs is to reinforce that narrative with the handling of all of the elements of line, colour and tone in the painting. The narrative may be only simple – a short anecdote such as the wheeling of birds above a field, as painted by Van Gogh, or it can be very complex, as in the bustling scenes of Flemish peasant life that Breughel delighted in.

A narrative painting usually portrays figures but could as easily be about inanimate objects such as trains or ships, for example. Even weather can convey a narrative of events past or incidents to come; an apparently calm landscape with green fields and grazing animals takes on a very different tenor if dark thunderclouds are massing threateningly on the horizon.

Your subject matter need not necessarily be drawn from life. We have a long history of narrative painting based on literature, so if you cannot go out to look for narrative paintings in the landscape, read and illustrate some books instead for inspiration.

▼ **PEOPLE AT DELPHI**
25.5 × 35.5 cm (10 × 14 in)
Four tourists descend from the stadium above Delphi, tired after the long climb up and down. They are silhouetted by the hard-edged shape of the light shining on the rock, reacting beautifully with the loose soft-edged tree on the left. The colour range hints at the narrative of heat and sun.

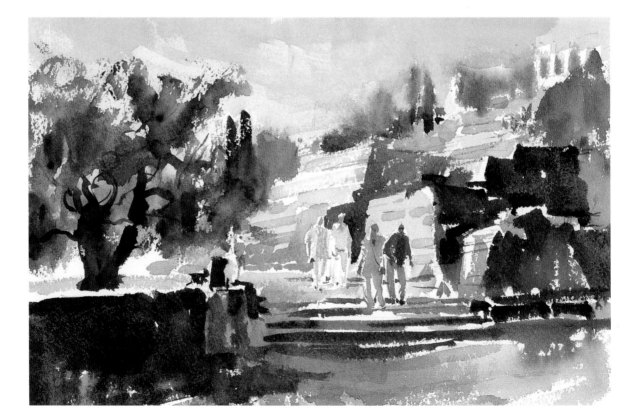

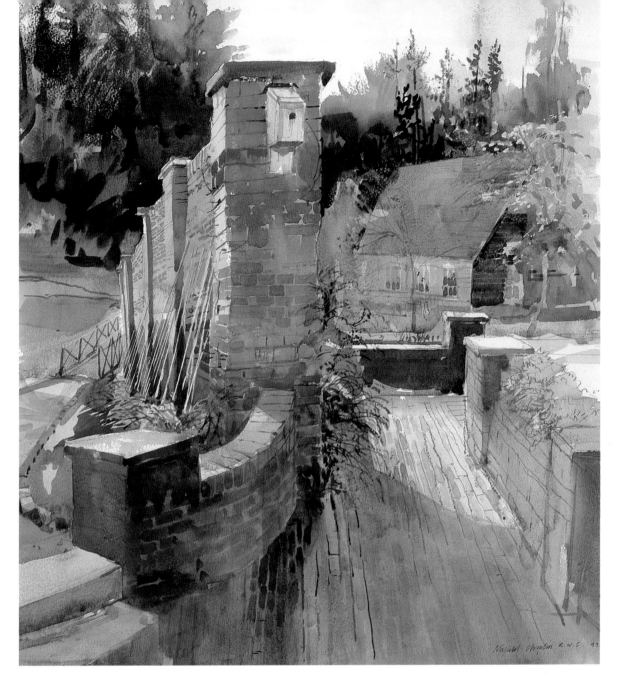

Hinting at the story

A narrative does not have to be obvious – it can be merely hinted at. An object can evoke a powerful sentiment, a fact that the Victorian story painters demonstrated in their moralistic and cautionary paintings; typical of the genre would be a painting of an opened letter on the bureau while in the distance, barely seen against the light, stands a sobbing girl at a window, suggesting the narrative. Shadows thrown from people or objects outside the picture can have as much presence as the figures themselves.

▲ TIT BOX

61 × 45.5 cm (24 × 18 in)

The steps to the left of the tit box on the wall await the entrance of the dramatis personae. The painting is not about the birds, it is about things shortly to happen – a hidden narrative.

The best narrative paintings demand that the viewer does some of the work in understanding the story. This encourages an involvement which is part of the attraction of the narrative landscape, so take care not to tell your tale too clearly.

DEMONSTRATION

The harbour

If you want a subject that is constantly changing, the sea is the thing; where there is water there is always reflected light from many different sources and the rising and falling of the tide can alter the whole composition in a short space of time. You can wait for the optimum time of day or seize the moment as I did in this painting of Folkestone harbour, sketched as soon as I stepped out of the car.

Palette

| Cobalt Blue | Permanent Mauve | French Ultramarine | Yellow Ochre | Indigo | Raw Sienna |

Brushes 45 mm (1¾ in) hake · No. 10 sable round
50 mm (2 in) nylon hake · No. 2 sable mop
Housepainter's brush

Yellow Ochre blended with Permanent Mauve to make a neutral

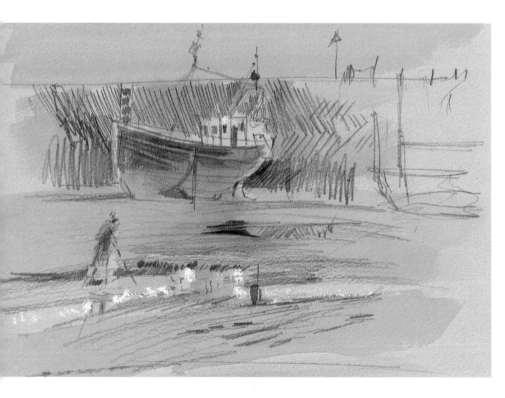

1 Using grey paper gave me the chance to work from mid-tone to dark and light, drawing with a pencil and using Chinese White paint to make notes about the boat cabin and the reflections. The danger that the boat and the foreground might become two disparate parts of the composition was avoided by using the white as a linking device. I moved the edge of the harbour wall in from the right to show the space beyond, trying several different points before I felt I had it right.

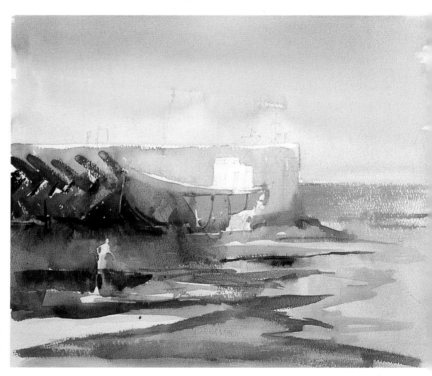

2 The first wash in the sky gradates from almost pure Yellow Ochre at the top with Permanent Mauve introduced with each successive stroke of the hake. I reversed the procedure in the water runnels in the foreground, creating a sense of space towards the horizon in the foreground and sky. Swapping to a No. 10 round, I added a little dark tone into the washes while wet to introduce the soft reflected tone from the wall.

3 A first tentative wash on the sea had proved too pale to show the highlights on the water so I made a second light pass with a nylon hake, the stiff bristles skimming across the surface of the rough paper. I began work on the boat, which is near the centre. Dark tones in the jetty to the left would provide an asymmetric tonal composition to balance this, and I made some herringbone marks as an indication of tone.

4 The dark of the jetty made the sky look weak, so I risked re-laying the wash. To put in the boat supports I used a drier brush to give quite a hard edge. The shadows were painted with a much softer edge to get a feeling of space between the poles and the shadows that would help to describe the shape of the boat. I also brushed in a dark tone on the trousers of the figure.

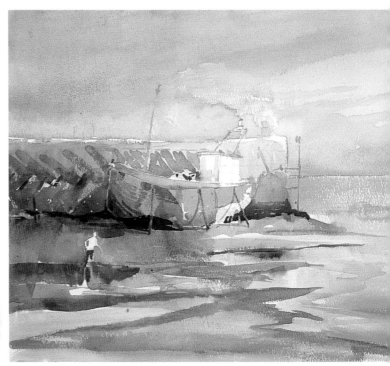

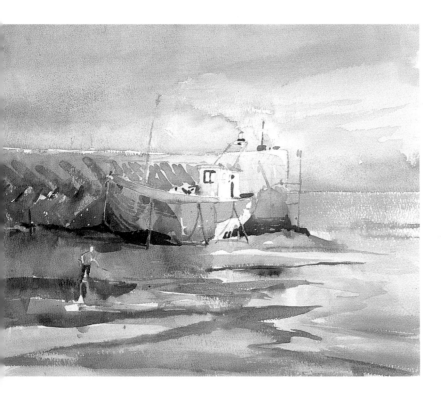

5 I added detail to the boat, giving volume by showing one window seen through another. There was so much hot colour round the figure that I felt the relief of some cool marks was needed, so I used French Ultramarine for the shirt and carried it down into the reflection. This had the effect of increasing the heat of the late evening sun and also made a point of interest.

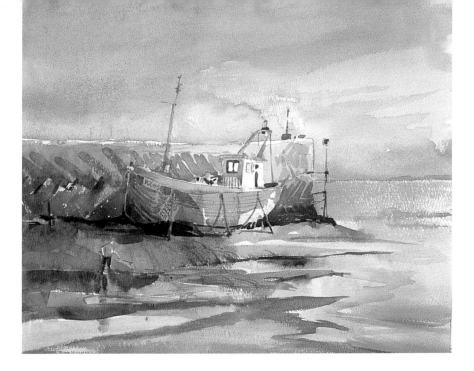

6 Most of the work so far had been fairly flat washes with little or no texture and the form of the sandbank under the boat was not fully explained, so I splattered some paint with a small housepainter's brush to give a random speckled surface to the sand. Using my No. 10 round, I also drew a few small lines just to show the sandbank is not a flat surface and to explain why the boat is sitting rather high above the water in the foreground.

7 I darkened the jetty still further to throw the boat forward and to increase the light on its side. The shadows were put in with a mixture of Indigo and Permanent Mauve, used fairly dry so that they are almost full tonal strength. I changed to a No. 2 sable mop for the really fine details of the rigging, pulling the brush along the line rather than holding it at a right angle like a pen.

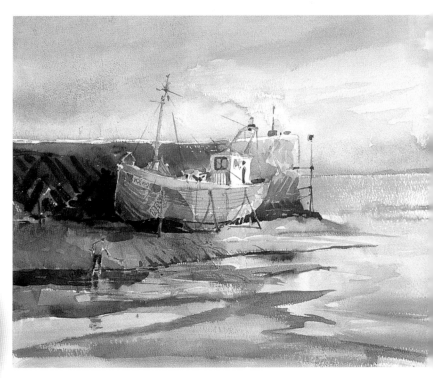

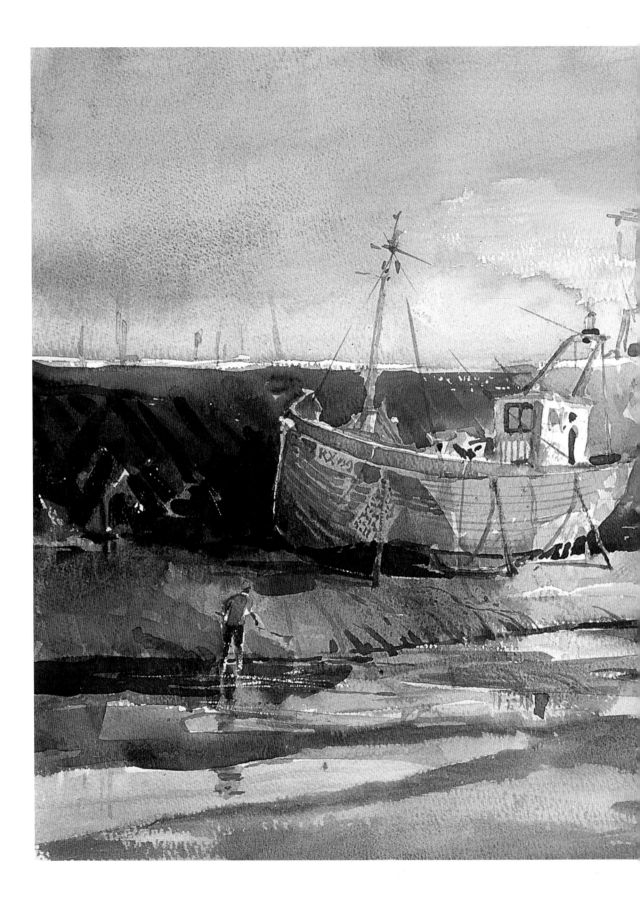

8 Putting in the railing along the harbour slightly broke the line of the rather too uniform top. I did a little scratching in the water where the figure is disturbing it, using brisk, strong lines to give an indication of movement. The gradated blue tone of the banding on the top of the boat and the breaking waves of the rising tide were put in by drawing horizontal lines with the brush. For the boat I used a French Ultramarine base with other colours run in so that it would not be too garish and fight with the shirt on the figure. The waves were put in with a greeny blue mixed from Yellow Ochre and Indigo, which was the same colour as the sea but in a darker form.

◀ **LOW TIDE AT FOLKESTONE HARBOUR**
40.5 × 51 cm (16 × 20 in)
Painting an object such as a boat which is quite a complex shape is a good test of drawing. It is impossible to make up the angles of the planks in the hull and the lines they follow, and I recorded them in my initial sketch done on the spot so that I could paint them realistically back in the studio.

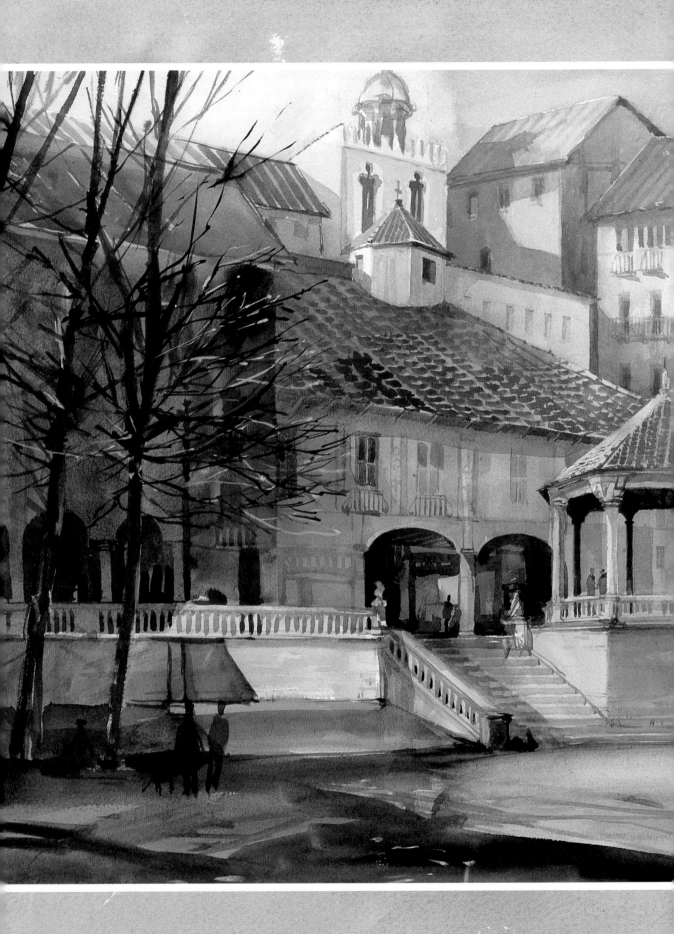

The Urban Landscape

After the peace and expanse of the countryside, painting in towns and cities brings an excitement all of its own. The paintings are usually much more densely filled with action and the colours can be unexpected and rich. On the other hand, inspiration may also await in a dusty and derelict factory or in a rusting dockyard.

◀ SPANISH VILLAGE
51 × 61 cm (20 × 24 in)
The warm tones and deep shadows of this Spanish village on a hot late afternoon were made to be painted. A detailed sketchbook study done on site provided information for this later studio painting.

Perspective

Perspective is the most obvious way of showing space and describing the volume of architecture. Although perspective may seem very complicated, an understanding of this rule is all that is needed at first: any lines that are horizontal and parallel to the direction in which you are looking (such as hedges, floorboards or the edges of a table or a building) will all appear to converge and will eventually meet in the distance at the same point on the horizon (the vanishing point).

This is known as one-point perspective for obvious reasons and it is the simplest of the rules

▲ **PAPER REELS, FLEET STREET**
41 × 51 cm (16 × 20 in)
This study for a mural relies on one-point perspective. Keeping the vanishing point to one side gives a more interesting composition and allows a more expansive view of the paper feeders on the right.

of perspective to understand. It is most apparent when you are looking down a path or road and will give immediate depth to your composition. As an exercise, lay tracing paper over a photograph of a receding road and draw the lines of the sides of the road; you will see that they will meet at a single vanishing point on the horizon.

▶ *Simple one-point perspective, where all the lines running horizontally and parallel with our line of vision – the sides of the path, hedge and roof wings – meet at one vanishing point.*

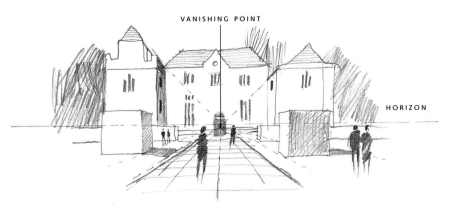

VANISHING POINT

HORIZON

Two-point perspective

When objects are not parallel to our line of vision, showing perspective becomes a little more complicated. You now need two sets of lines to account for the convergence in two directions. These lines will share the same horizon, or eye level, but they will have different vanishing points. This is two-point perspective. The difficulty is that in constructing a drawing one of the vanishing points for an obliquely placed object may well be off the page, but once you are familiar with the principle you will be able to imagine the angle the lines should take.

However imaginative your vision, excellent your brushwork and strong your composition, the eye will always go straight to a mistake in perspective, so it is important to get it right. As always when learning, start simply and understand each step; do not attempt two-point perspective until you have mastered one-point. Perspective can be as simple or as complicated as you make it, but as long as you have understood these two basic principles you will be able to create a sense of distance and construct an apparently solid building with volume.

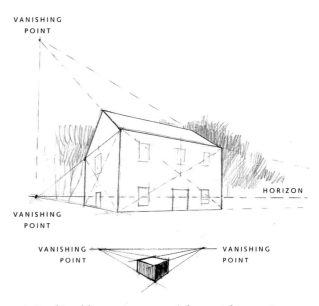

▲ *In this oblique view one of the vanishing points is off the page. Diagonal lines on the house cross at the centre, showing the position of the doors.*

▼ **DOCKYARD**
45.5 × 63.5 cm (18 × 25 in)
A two-point perspective is subtly present in the reflections of the sky in the water patterns and takes the eye across a large expanse of foreground.

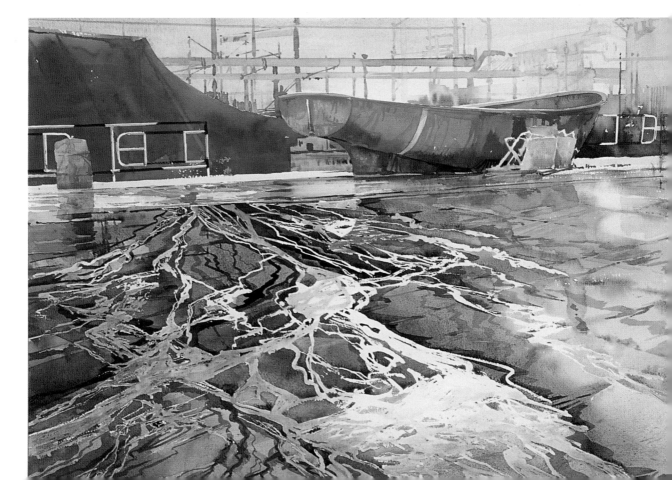

Approaches to architecture

Working in towns and cities can be exciting and stimulating, but there are pitfalls. Trying to achieve architectural correctness while still preserving the emotional sense of the place is a balancing act that needs some thought. Obviously the buildings need to be credible and for this the perspective needs to be right, but having achieved this solid basic drawing the handling of the details is a matter of painting temperament. Both the highly detailed and expressionist approaches are valid, and it is up to you to decide which you feel most comfortable with and satisfied by.

Setting the scene

Being aware of the materials used in the building will go a long way to establishing a recognizable location. Warm brickwork catches the light in quite a different way from polished marble, and a modern glass office block will need to be painted mainly as reflections. Notice how the lower windows will reflect the buildings behind you and consequently be dark while the top ones will tend to reflect the sky, giving an interesting tonal progression across the painting. The angle of reflection increases as you look up, so windows nearly always lighten progressively towards the top of a building.

City paintings generally have strong linear designs that are often vertical; lamp-posts, street signs, telephone boxes, hurrying figures, all there to be used. Keep a city notebook for small, fast sketches full of movement and incidents.

▼ TRAMS IN BREMEN
45.5 × 58.5 cm (18 × 23 in)
Working at night in cities introduces you to a whole new range of colours and tones. The figures waiting for the tram are barely indicated but add human interest.

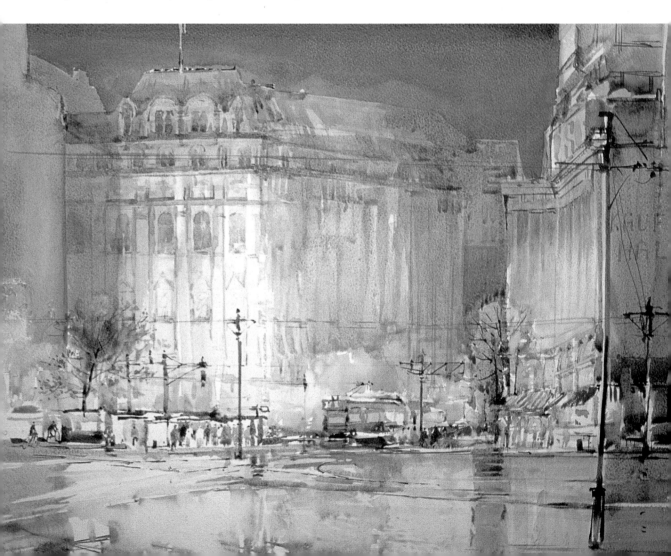

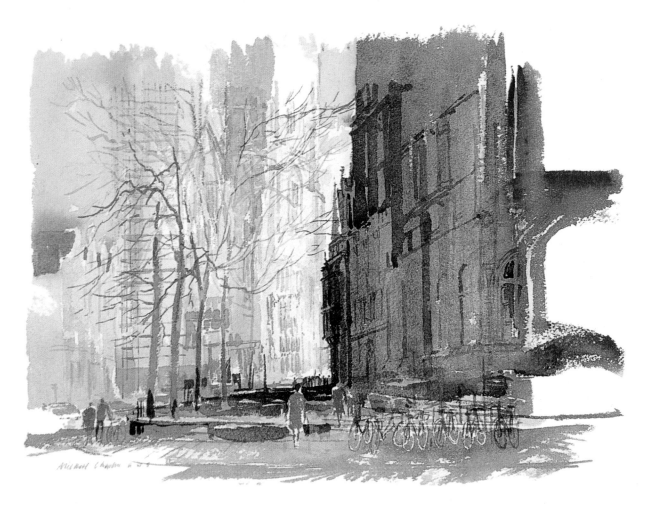

Dealing with details

In order to avoid your paintings becoming too architecturally dry, leave some areas only loosely indicated. This will guide the eye to other areas where the treatment is more detailed – but try to resolve detail to essential simplicity or you risk the painting looking overworked.

Sketch the same view at different times of day to see the effect of different linear shadows and areas of shade. Advertising hoardings are mundane but provide lovely splashes of colour. Because they are shouting for attention they are bright and brash – excellent to place here and there in sombre areas of shadow in order to keep those areas buoyant and alive.

▶ PALAZZO IN VENICE

25.5 × 33 cm (10 × 13 in)

This painting is about flat design, colour and texture. The sky is ignored and only the delicate shadows and the perspective on the left suggest any depth in the composition.

▲ BICYCLES AT YORK MINSTER

25.5 × 30.5 cm (10 × 12 in)

This preliminary study for the painting on page 42 resolves the complexity of the bicycles into a simple texture so as not to hold the eye for too long. The light and dark tones have been explored.

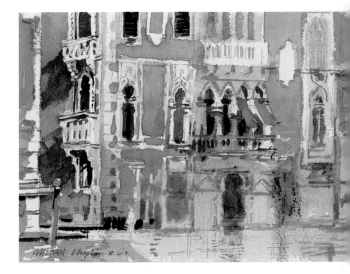

Urban detail

Collecting detail in a sketchbook is one of the bonuses of being an artist. You learn so much about buildings when you draw them: how they are made, the materials they are made of and their history are all revealed. Sketches will also recall the sense of a place when you are back home more than any photograph or postcard.

Compact working materials that fit into a pocket are all that you need, but try to carry a variety of media. Decide whether the interest in a detail is about colour, texture or line and select a medium that best deals with this. It is difficult to make notes about peeling layers of coloured paint with a pencil, and an area of intricate architectural detail will lose all sense of finesse if you draw it with charcoal.

Some people find painting in public in an urban environment embarrassing, but the beauty of sketching is that you can tuck yourself into a doorway with a small pad in your palm and work unobtrusively in even the busiest street.

◀ RIALTO BRIDGE, VENICE

15 × 20.5 cm (6 × 8 in)

Half an hour in a doorway opposite the church of San Giacomo with the Rialto Bridge to the right was time well spent. The light changed from dusk to dark as I drew and the stallholders gradually lit their lamps. I used a fountain pen and added simple washes of tone and some indications of colour.

▶ ROOF IN CALAIS

10 × 10 cm (4 × 4 in)

Do not forget to look above your head – much ground-floor detail is recent because shop fronts change with usage, but the details of upper floors often preserve the architecture of past eras. A cautionary note: try to hold your sketchbook square. This one was held at an angle and it has affected the perspective.

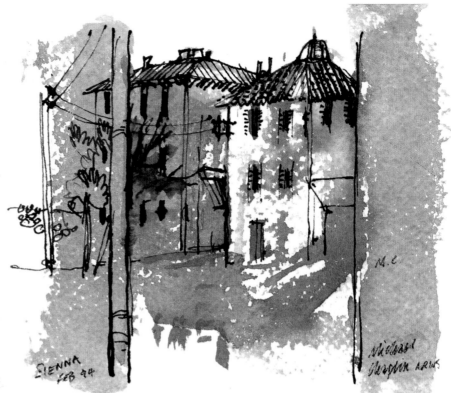

▶ **SIENA**

10 × 12.5 cm (4 × 5 in)

Rough-surface paper was ideal for hinting at the texture of old sun-baked buildings.

▼ **BARCELONA**

7.5 × 7.5 cm (3 × 3 in)

Juxtaposition of the man-made and natural provides an interesting counterpoint.

▼ **BRIDGE, VENICE**

18 × 25.5 cm (7 × 10 in)

A study made directly in paint is still basically a drawing but gives instant notes on both structure and tone. It is only a short step from here to starting to develop the study as a more finished painting.

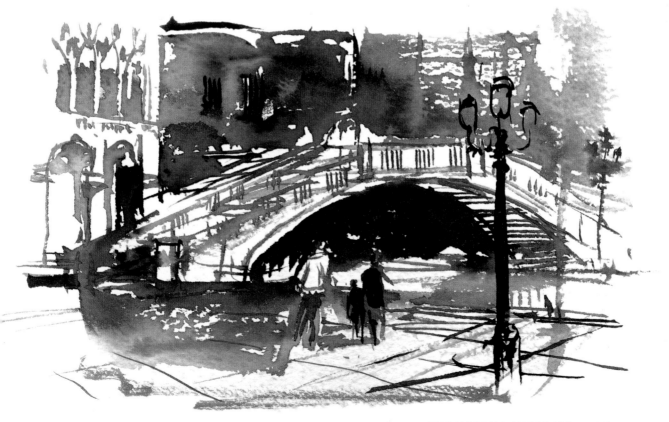

Adding figures for scale

When you work in urban surroundings you cannot help noticing the people present within them, engaged in a variety of activities. Singly, in groups or in large numbers, they provide interest in any painting. Most obvious is the narrative element they contribute, but the sense of scale that they give to buildings is equally important.

The choice of whether to describe figures in precise detail or simplify them to a few general marks is a personal one, but no matter how you treat them try to see them as part of the painting as a whole and do not suddenly adopt a different style. A common mistake that people make is to pick up a tiny brush and paint tight figures within a lovely loose landscape, with the result that they look imported from a different picture.

It is not an immutable rule, but groups of figures do tend to fit more happily on the paper in odd numbers; paint three figures rather than two or four, for example.

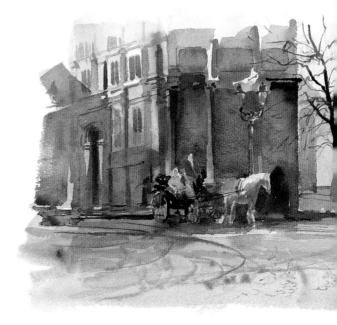

▼ FOOTBALL

25.5 × 35.5 cm (10 × 14 in)

A youthful game of football in the Parc Guell in Barcelona is captured in situ, drawn fast with a brush. Several tussles are breaking out and everybody is having fun. They occupy the space of the painting like a stage set.

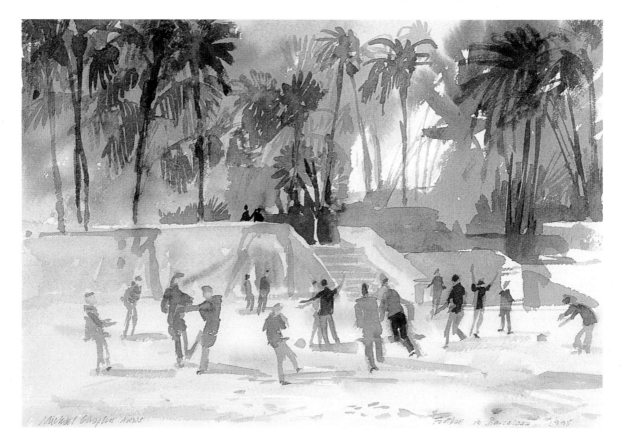

▲ CARRIAGE RIDE IN
BRUGES
20.5 × 25.5 cm (8 × 10 in)
*You do not get long to
make notes of passing
incidents such as this.
Not every sketch has
to be developed into a
finished painting –
sometimes a simple
study exists quite
happily as just that.*

► PEOPLE IN ST
MARK'S SQUARE,
VENICE (detail)
*Without the figures the
sense of the height of
this arch would be lost.
As a useful guide to
scale it is worth while
imagining the figures
in the buildings to
judge whether they
would fit the height of
the rooms as indicated
by the windows.*

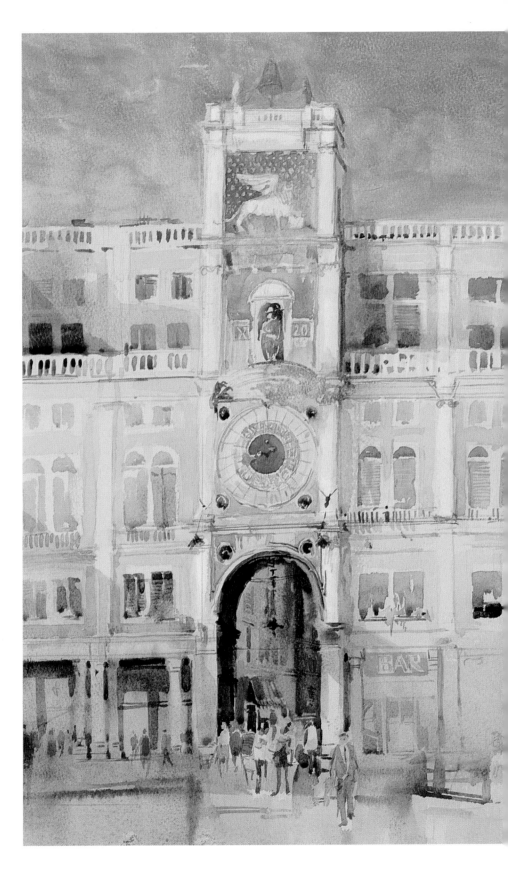

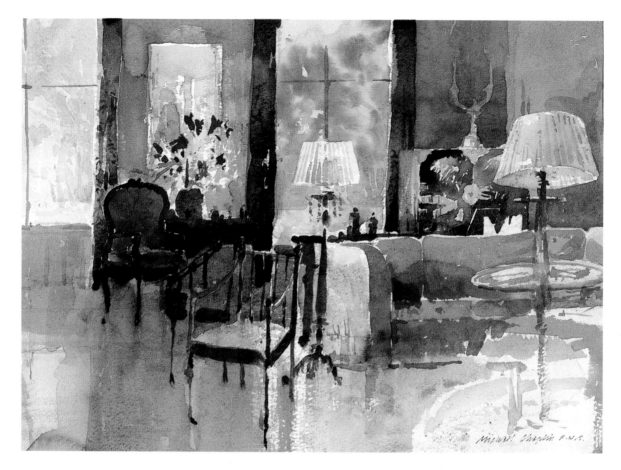

Interiors

Paintings of interiors are very satisfying to do. They can be as simple or as complex as you care to make them, and you often have control over conditions that you lack in the outside world. Lighting effects in a single painting, for example, can include almost silhouetted tones against the natural light from a window and the warm glow of artificial light from a lamp, a test of observation and colour mixing if ever there was one.

The perspective of interiors is normally simple one-point, but colours and tones can be very complex. It takes the eye quite a while to adjust to subdued interior light and perceive the true colours and tonal relationships, so spend the first minutes deciding upon subject, size and format and doing some thumbnails of details just to get to know the room. This is particularly the case with large, stately rooms where the light from each source peters out very quickly.

▲ **SITTING ROOM AT BOUGHTON MONCHELSEA**
28 × 38 cm (11 × 15 in)
The depth of this room was shown by describing the hardness of the wooden furniture with fairly precise lines but making the window mouldings broken and indistinct.

The choice of interiors is wide, from cottage kitchens to huge, resonant railway stations, but they nearly all differ from landscape painting in the same respect: they have a foreground and middle distance but usually do not have a far distance. This lessens the ability to use aerial perspective, so consider using hard and soft edges or altering the colour balances subtly between hot and cool to help show the space.

Interiors can be quite static, claustrophobic images. Be aware of this in your thumbnail sketches and if need be introduce a hint of life – perhaps a cat curled up asleep on a sofa, a dog in front of a fire or a figure polishing a sideboard.

Plenty to learn

When bad weather confines you to the home, interiors offer plenty of opportunity to learn. Still life is an obvious subject, but as an exercise try lighting from behind with a table lamp for strong tonal drama. By using a very strong-coloured light bulb or shade it is possible to flood the room with one colour, giving you the chance to try a study in monochrome where you can concentrate upon tone.

The kitchen can supply a variety of shiny objects such as the kettle and saucepans that will give interesting distortions. Do large-scale drawings of what you can see, including your own self-portrait. To sharpen up your observation, try drawing familiar objects such as telephones from memory and discover how accurate you can be. Set your own curriculum for study and you will be a better artist next time you go out on location.

▼ **ATHENS MUSEUM**

25.5 × 40.5 cm (10 × 16 in)

The sense of seeing through into another room is heightened by stronger colours and tones in the foreground. The figures here are loosely shown so the eye dwells on the people in the gallery beyond.

▲ **THE GLASS INKSTAND**

25.5 × 20.5 cm (10 × 8 in)

This delightful object of glass and brass posed particular problems in showing different materials. A challenge such as this really sharpens up your eye and technique.

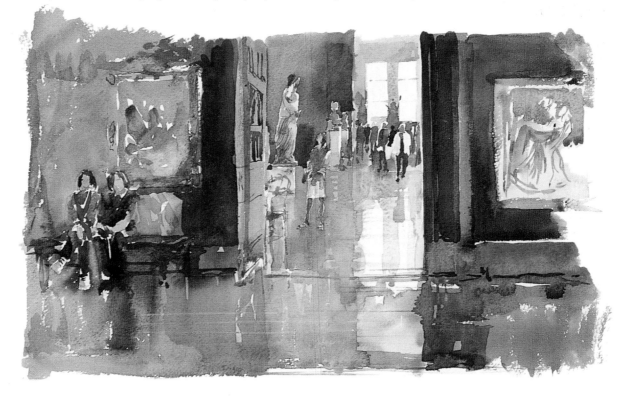

Industrial scenes

Industrial locations are not everyone's favourite subject matter, but there are many eye-openers when encountering a new challenge. Of course safety is an important consideration – I once painted down in the sewers wearing full wet gear and a safety line (once in a lifetime is enough!) – but there are attractions to balance against any difficulties. With industrial subjects you often find that because the buildings and objects are made for a specific purpose they have a rightness to them, with a satisfying strength of shape, line and colour. They have already been designed, whereas with nature you have to extract the design you want to impress on a painting. Indeed, the colours are often man-made and

difficult to find in the usual watercolour box, so it is worth taking black and white with you to mix the pastel tones.

Faced with unfamiliar objects, I like to go and feel them. Most painting comes from our perception of surfaces, and discovering whether they are cold, warm, rough, smooth, shiny or matt gives me an indication of how to treat them.

▼ BOILERS, CHATHAM DOCKYARD
45.5 × 56 cm (18 × 22 in)
These boilers made a great focal point of colour in the low-key tones of the building. Using granulating Neutral Tint for the background wash gave depth, while splattered texture in the foreground indicated the surface. There are few soft edges but I tried to show the different textures within the hard shapes.

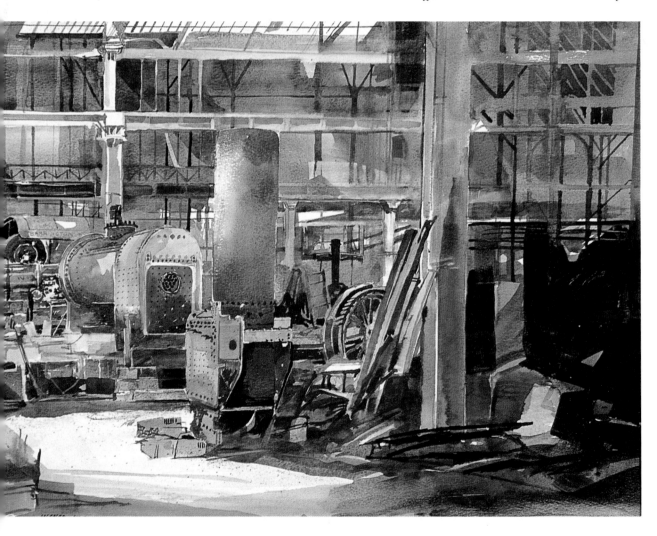

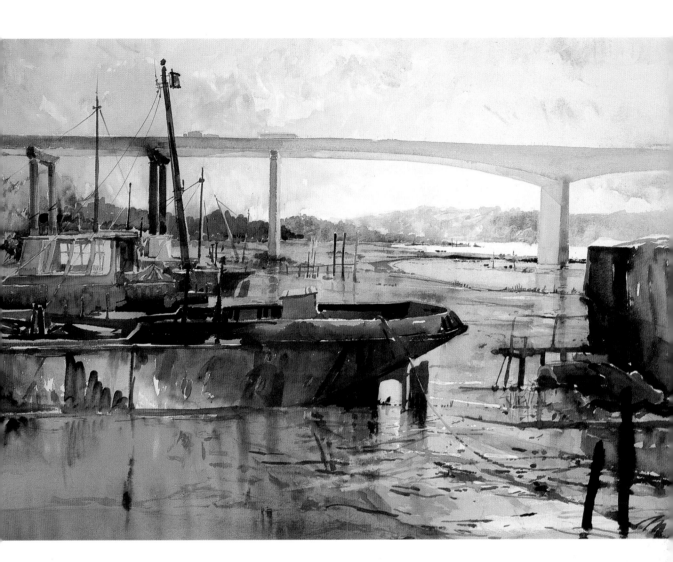

Finding the unexpected

Objects and materials considered unsightly in everyday life often have their own inherent beauty once prejudice is put aside. Rusty corrugated sheeting may contain beautiful tints and colours and have interesting effects on a shadow cast across it; oil floating on water refracts light to make iridescent colour; even scaffolding and cranes have a complexity and grandeur that is easily missed in the bustle of everyday life.

On a much smaller scale, keep an eye out for technical objects such as the workings of an old-fashioned sewing machine or the cutting blades of your lawn mower – they all make good drawing exercises. Because you will not have any preconception of what they should look like you

▲ MOTORWAY BRIDGE

76 × 91.5 cm (30 × 36 in)

This painting of a high-level bridge over the estuary near my home contains most of what has been considered in this book: scale, tone, colour, line and a sense of magic coming from the everyday. It is a large watercolour that provided scope for loose, colourful washes.

will have to observe them carefully, measuring length and width from point to point, looking at angles and drawing unfamiliar shapes such as cogs and springs. It will improve your ability to observe and record and this will feed back into all your drawings and paintings, so make use of everything the world has to offer and be intrigued and interested by it all.

DEMONSTRATION

The street market

I spent one November day drawing in Athens and was hurrying back to the hotel for dinner when I was arrested by the sight of the vibrant colours of the fruit market reflected in the dampness of the road. I had to stop and make a quick drawing in my sketchbook, noting also the colours that were of main importance – the red of the fabric in the dark of the overhanging shelter and the glowing yellow light across the road.

Palette

Cadmium
Red

Cadmium
Yellow Deep

Permanent
Mauve

Burnt Sienna

Coeruleum

Brushes 45 mm (1¾ in) hake · No. 6 sable mop
No. 10 sable round

Permanent Mauve blended with Burnt Sienna to
make a black

1 My initial sketch was done with a fountain pen and ink. Because it was watersoluble ink I was able to drag tone from some of the darker tones in the building down to the foreground to show the wet road. The figures do not freeze an exact moment in time but were added during the course of the sketch as they passed. The light changed very quickly at the end of the day; by the finish the sky was really dark and the lights of the market stalls looked even stronger by contrast.

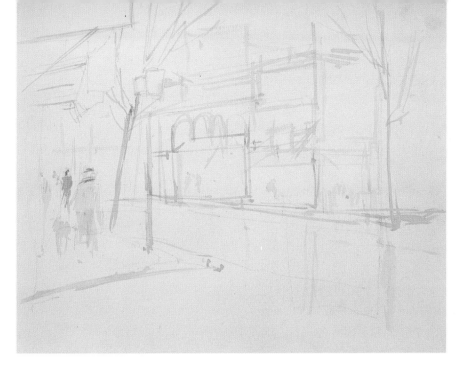

2 Changing the format slightly to enhance the feeling of the vertical rhythms between the buildings and the light falling across the wet foreground, I began laying down a simple drawing with a brush and very cool Coeruleum that would vanish beneath later washes. So that I could keep drawing without breaking concentration to refill the brush I used a No. 6 sable mop that holds a lot of paint but comes to a perfect point.

3 The next step was to put the first three washes over the top of the drawing, mainly working on the idea of some areas being very cool and others being very warm. Some of these fairly light washes survived in the finished painting but I was really using them to identify intimate warm areas and cool recessive areas looking down the street. I used mainly Cadmium Yellow Deep for the former and Coeruleum for the latter.

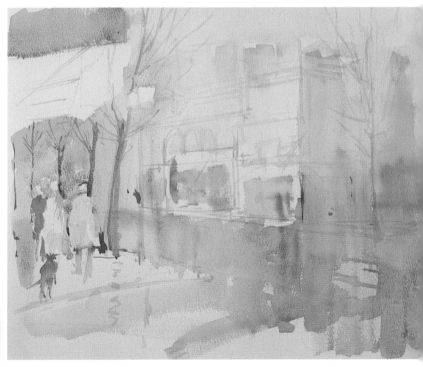

4 I put in the extremes of colour in the picture – some strong red fabric and the light coming from the market windows – because those colours are the points of interest that needed establishing early on. Using mainly Cadmium Red and Cadmium Yellow Deep, I applied the paint with fairly tight edges in order to give very defined shapes.

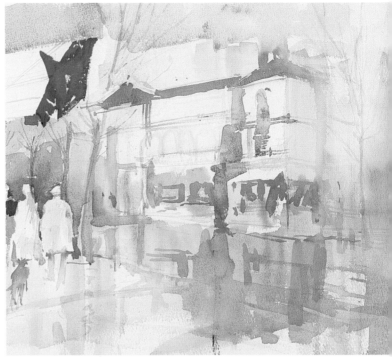

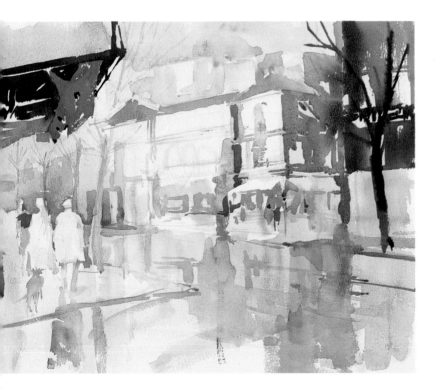

5 Adding very dark tones around the canopy gave me an indication of the strongest tonal value in the painting and also threw the red forward so that I could see the balance of that red when it had a dark tone against it. I used a mixture of Permanent Mauve and Burnt Sienna, which almost makes a black but can be swung towards either a cool or a warm dark.

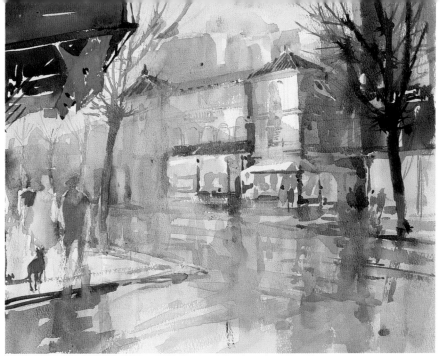

6 Using a 45 mm (1¾ in) hake, I began putting in the mid-tones in fairly broad washes to banish nearly all the white paper that I was now left with between the strong colours and tones. I isolated the white in the diagonal light of the building opposite and the reflections on the near left, which was crucial to keeping the painting alive in those dark areas. The washes contained quite a lot of granulating colour to give them texture.

7 The initial drawing had disappeared beneath the washes, so I now began to re-establish the architecture of the painting using cool blue and dark tones in Permanent Mauve and Burnt Sienna. I added detail to the figures in front of the lit-up window on the opposite side of the road, put in more linework in the trees and made little additions to the narrative elements of the dog and the man with the basket of fruit.

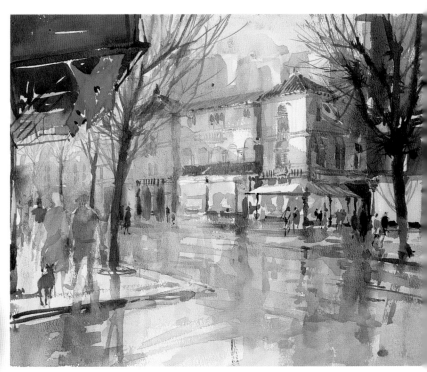

8 The final details were to put some scratching on the road to reinforce its perspective and on the shoulders of the figures on the left to isolate their colour out of the background tones. I put some granulated blue wash loosely into the branches of the trees on the right, then scratched in some white to show where the light behind was picking up on the dampness of the branches.

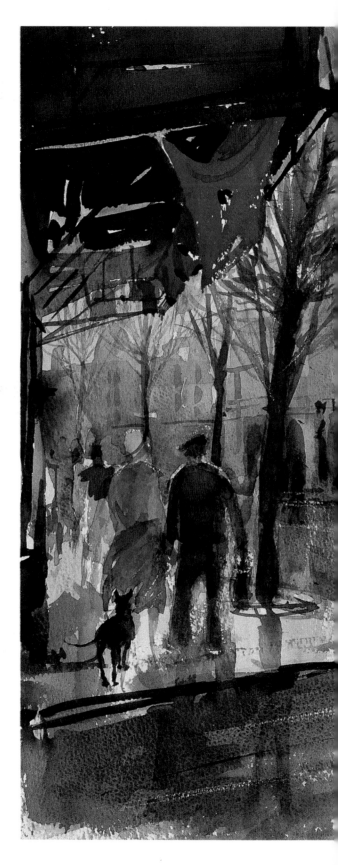

▶ EARLY EVENING, ATHENS STREET

41 × 51 cm (16 × 20 in)

This apparently mundane subject of a quiet moment in a normally busy street is full of colour and vigour. The only remaining piece of white paper delicately catches the last of the evening light on the stuccoed building on the right.